STRENGTHEN
Your PAINTINGS *With*
DYNAMIC
COMPOSITION

FRANK WEBB

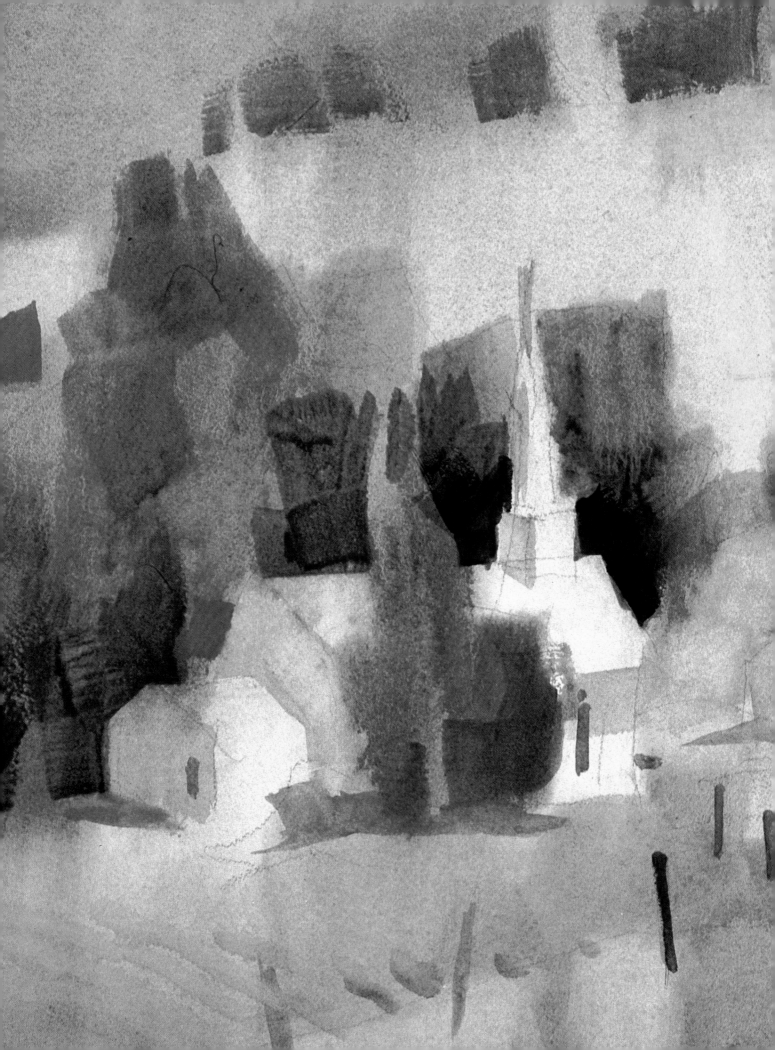

ELEMENTS OF PAINTING SERIES

STRENGTHEN
Your PAINTINGS *With*
DYNAMIC
COMPOSITION

FRANK WEBB

NORTH LIGHT BOOKS

CINCINNATI, OHIO

About the Author

Frank Webb is a Dolphin Fellow of the American Watercolor Society. He is also a member of the Allied Artists of America, Audubon Artists, the Rocky Mountain National Watermedia Association and many other art organizations. He is listed in *Who's Who in American Art*, *Who's Who in the East*, and has authored two earlier books, *Watercolor Energies*, 1983, and *Webb on Watercolor*, 1990. A guest instructor, juror and lecturer, worldwide, Webb has received over eighty major awards including the American Watercolor Society Bronze Medal of Honor, the Mary Pleissner Memorial Award, and the Walser Greathouse Medal. He has represented the American Watercolor Society in international exhibitions in Canada, New York, England, Scotland and Mexico City. A professional artist since 1947, Webb's studio and Victorian home are in Edgewood, Pennsylvania, a suburb of Pittsburgh.

Strengthen Your Paintings With Dynamic Composition. Copyright © 1994 by Frank Webb. All rights reserved. No part of this book may be reproduced in any form or by any electronic or mechanical means including information storage and retrieval systems without permission in writing from the publisher, except by a reviewer, who may quote brief passages in a review. Published by North Light Books, an imprint of F&W Publications, Inc., 1507 Dana Avenue, Cincinnati, Ohio 45207. 1-800-289-0963. First edition. Printed and bound in China.

This hardcover edition of *Strengthen Your Paintings With Dynamic Composition* features a "self-jacket" that eliminates the need for a separate dust jacket. It provides sturdy protection for your book while it saves paper, trees and energy.

98 97 96 95 94 5 4 3 2 1

Library of Congress Cataloging in Publication Data

Webb, Frank.
 Strengthen your paintings with dynamic composition / Frank Webb.
 p. cm. — (Elements of painting series)
 Includes bibliographical references and index.
 ISBN 0-89134-550-7
 1. Composition (Art) 2. Painting—Technique. I. Title.
II. Series: Elements of painting.
ND1475.W43 1994
751.4—dc20 93-29271
 CIP

Thanks to each artist for permission to use their artwork.
Edited by Rachel Wolf
Designed by Paul Neff
Cover illustration by Frank Webb

METRIC CONVERSION CHART		
TO CONVERT	**TO**	**MULTIPLY BY**
Inches	Centimeters	2.54
Centimeters	Inches	0.4
Feet	Centimeters	30.5
Centimeters	Feet	0.03
Yards	Meters	0.9
Meters	Yards	1.1
Sq. Inches	Sq. Centimeters	6.45
Sq. Centimeters	Sq. Inches	0.16
Sq. Feet	Sq. Meters	0.09
Sq. Meters	Sq. Feet	10.8
Sq. Yards	Sq. Meters	0.8
Sq. Meters	Sq. Yards	1.2
Pounds	Kilograms	0.45
Kilograms	Pounds	2.2
Ounces	Grams	28.4
Grams	Ounces	0.04

Dedication

This book is dedicated to Smitty Webb. She aids, abets, advises, criticizes, and speaks the truth in love. And not only these, but laughs at my jokes.

Acknowledgments

When the paper was still blank, Greg Albert made many helpful suggestions. At first brush, Wendy Webb Kumer helped craft the text. Again, North Light Books editors Greg Albert and Rachel Wolf were there, aided by Kathy Kipp and Terri Boemker. Mary Junewick's copyediting was the source of helpful suggestions and needed corrections. Barbara McGovern cheerfully typed the manuscript. The works of guest painters add scope and quality—eight of them have been my students. Most are longtime friends. Individually and collectively they seethe with aesthetic power. I thank each one of them. Now that the pages are full, I thank you, the reader, for adding this book to your library.

Preface

For years my students, wishing to be re-Webbed, asked me to suggest a book to augment my teaching of composition. I, too, long awaited such a book to recommend. Then North Light wanted a book to round off a series of basic instructional books. So here it is—the book sought by students and myself. It not only propels the beginner through the composition barrier, but is a reference for the more experienced painter. It should be read, marked, learned and inwardly digested by re-reading.

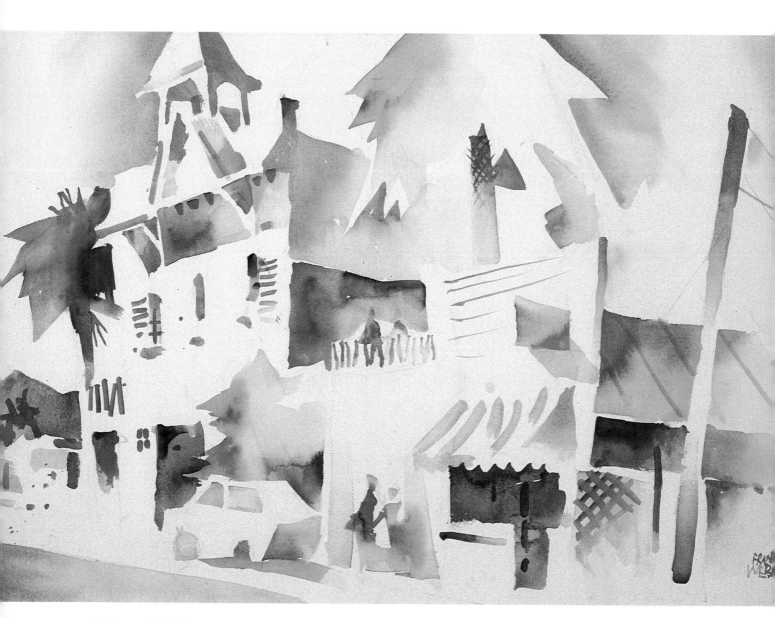

Calistoga City Hall
by Frank Webb
Watercolor
15" × 22"

Contents

Introduction

A painting is a love letter, authored not by a poet who uses words, but by an artist who fashions paint marks on paper or canvas. The first thing the painter needs is a *feeling* about the subject and its possibilities as a painting. Next come the marks on the paper or canvas. There are seven kinds of marks. Though they usually combine to give an illusion we call a picture, each mark lives a separate life. How are they to be organized? The beginner usually believes the marks must only match the subject or the model. The more advanced beginner comes to realize the subject must be *re-created* with qualities and characteristics that are either latent or nonexistent. To create these desired qualities the painter works with seven compositional ideas. In this book I define and discuss these fourteen essential words: *seven marks* before the eyes and *seven ideas* behind the eyes. This forming process is called design or composition. *Pictorial composition is the organization of emotional experience and graphic marks into the most economical, expressive, unified visual communication.* Composition is more important than fact, technique, or subject. As Charles Movalli said to me, regarding composition, "What else is there?"

State of the Art

Why is composition ignored by many painters? First of all, many who are painting do not realize they are composing, just as the fish doesn't know that he is wet. Since the French Impressionists, there has been a feeling that a painting must be an improvisation, and that composing thwarts improvisation. Others stray because they are so focused on technique, materials and media. Then there are those impatient ones who are so anxious to slap on paint. Then, too, laziness takes its toll, for composing is hard work and we wish to avoid not only work but pain. And last, but not least, composition is ignored by painters who cater to a public conditioned by photography, believing a picture must have elaborate detail. Thus the world is overloaded with non-composed pictures insinuating themselves into every corner of our lives.

Many of us long for the subject of our paintings but want more than a model-bound copy, more than a pretty picture, more than a telling of a story and more than an enlarged doodle. We want our picture to have aesthetic validity and to have an all-important unity that only good composition can furnish. We want the picture to look good even when upside down. In short, we want to have it both ways: good representational images combined with appealing composition. At the same time we do not wish to be straitjacketed into arbitrary rules. We want our intuitive groping to act as the motor, and composition to be the transmission of our creative vehicle. It is what we put into our paintings of ourselves that is significant.

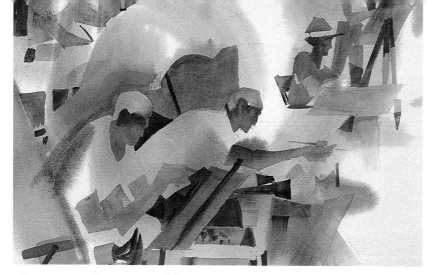

The Way of Composition

Composition springs from gesture and is concerned more with forces than with objects. The basis of composition is irregularity. As Auguste Renoir said, "One can state that all truly artistic production has been conceived and executed in conformity with the principle of irregularity." Though composition is a deliberate and intending activity, so also is it a responding activity. It should not only precede execution but spring lifelike out of countless decisions made during process. Thus, composition is not something thought out and settled in advance, it continues right up to choice of frame and placing of your signature.

Composer vs. Performer

In music, the composer and the performer are often separate persons. Also in painting there are painters who are known as performers, for example, Frans Hals who painted alla prima with sure touches in one layer. Then there is the composer type such as Cézanne, credited with much originality, even though as a performer he seems inept. Better to be both performer and composer. While there is a limit to improving one's dash and bravura, there is more potential for continued growth as a composer.

No Easy Task

It is easy to make an eyesight copy of a model, still life or landscape. It doesn't require courage to paint what you *see*. To paint what you *think and feel* takes guts. Composition gives you the tools to do this. With practice your art will have greater content because it combines seeing, thinking and feeling. It will discover connections where none were previously seen. "It is a happy thing that there is no royal road to poetry," said Gerard Manley Hopkins. The road to art is the way of trial and error. One of the road's biggest obstacles is design or composition. Not only does the work of art need designing but also the worker. By the work we judge the worker. According to Max Schoen, "The commonness of the common man is his satisfaction with the common." Can you afford to ignore composition?

Good News

Dynamic composition can be learned. It is an acquired skill. The work of the professional painters in this book gives you an over-the-shoulder look at how composition ideas are applied. Armed with this information you can build a powerful picture and, equally important, you can analyze and improve a work that has gone wrong. You may embrace the representational tradition with all its psychological values yet combine it with the flash, wit and horse sense of good composition. It is exhilarating to use the mind wholeheartedly as well as the eyes and hands.

—*Francis Hubert Webb*
Pittsburgh, Pennsylvania

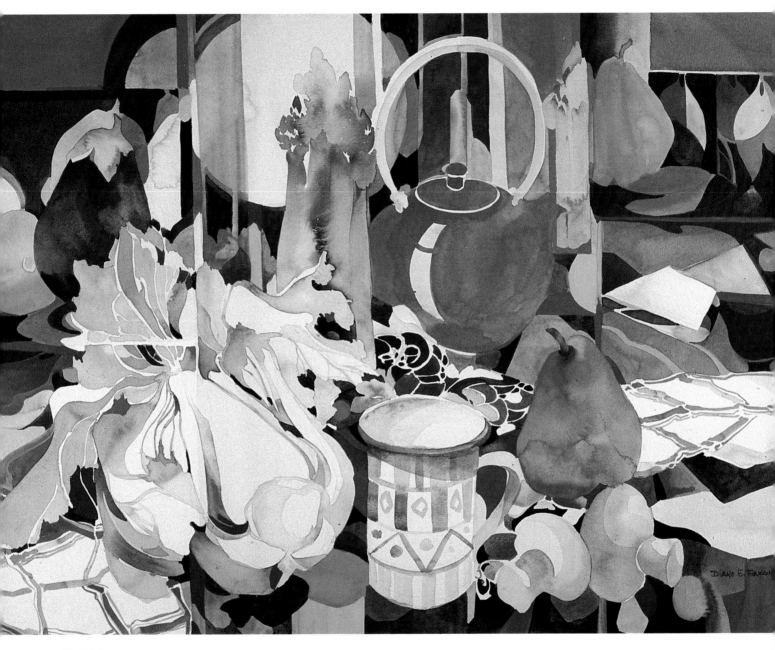

My Kitchen
© 1992 by Diane Faxon
Watercolor, transparent and opaque
22″ × 30″

Diane "wallows in pattern." She builds
with a unity of color, value and shape—
both positive and negative.

These fourteen words are the composer's vocabulary. Memorize them.

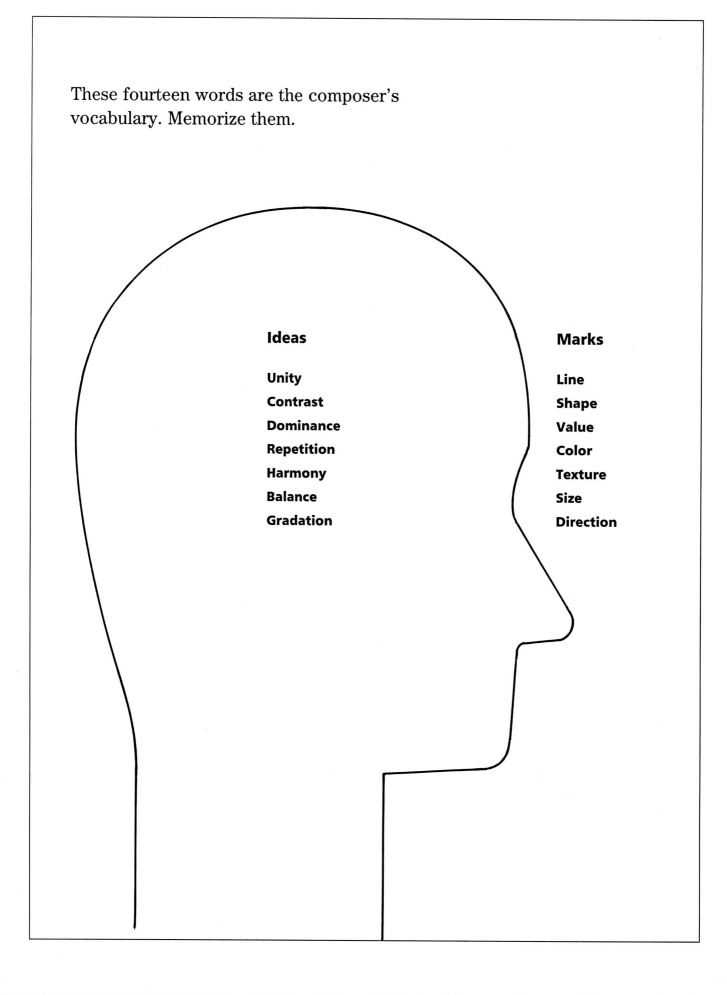

Ideas

Unity
Contrast
Dominance
Repetition
Harmony
Balance
Gradation

Marks

Line
Shape
Value
Color
Texture
Size
Direction

Definitions at a Glance

The contents of this book are not strictly sequential. If this were possible its contents could be apprehended all at once in the same way we behold a picture. But the brief definitions listed here are in proximity so that you can quickly review and compare them.

Seven Kinds of Marks

Paintings are not made of people, trees and skies. They are built with marks put on a surface. These marks are more real than the illusion they usually present. The marks in themselves are static and dead until they are sparked by the emotions and compositional ideas. These marks do not exist in isolation, they coexist; but they may be regarded separately.

Line. Line is contour of shape. A line may be straight or curved. Though line has many other attributes (mostly as elements of movement or gesture) here we limit line to a bare bones contrast of straight vs. curved.

Shape. Shape is an image depending on the relative position of all parts comprising its outline. It may be bounded by line, points, values, colors or textures. Shapes are flat on the picture surface.

Value. Value is the degree of luminosity—the relative lightness or darkness of a line or a shape. Values are conceived as comparative increments on a scale made up of tonal media. Relative values suggest variations of light intensity.

Color. A shape may have color. The spectrum of color includes red, yellow, blue and other hues. Color, the most subjective of the art elements, depends on the eye of the beholder. Color for the composer is always contextual. It has four characteristics: hue, value, intensity and temperature.

Texture. A shape may be rough, smooth, matt or glossy. Texture is apprehended by touch or by sight. Visual texture is the chief concern in painting. With art media, many textures of nature can be simulated. There is also the inherent texture of art media.

Size. Synonyms for size are: proportion, measure, scale and ratio. Shapes may vary in size and space; intervals may also vary in size. Size is relative and comparative—for example, large, middle and small sizes.

Direction. Lines, shapes, and the space intervals between them have direction. There are only three possible directions in a picture. They are horizontal, vertical and slanted. Directions are relative to the border and to each other.

Seven Design Ideas

As verbs activate language, so these ideas organize and relate images on the picture plane. They animate and unify the inert elements, establish character, and result in beauty.

Unity. Unity is an integration—the oneness and completeness of a designed structure achieved by the total effect of all its parts. Unity results from initiating contrasts and then resolving contrasts by providing dominances. It can also be achieved by repetition and harmony. Unity is the single most important quality in composition.

Contrast. Contrast is opposition, conflict or complementarity. The presence of contrast creates interest. It can be violent or mild. Contrast is a sovereign principle in any art style. It is the plot in fiction.

Dominance. To dominate is to rule by superior force. Dominance is achieved by subordination of a competitor. Dominance resolves contrast, producing unity. Dominance is character. Contrast and dominance work together to create unity.

Repetition. Repetition may be exact repetition or may include variety. The composer may repeat hues, shapes, values, colors, textures, sizes and direction. Echoes and resemblances pull the work together, giving it a visual theme.

Harmony. When art elements have similar attributes they are harmonious. Harmony takes place somewhere between the extremes of boredom and chaos and combines stability with change. Units more closely similar are harmonious while extreme contrast moves toward discord.

Balance. Opposing visual forces must be balanced. Marks are not only seen but must be felt as forces within the pictorial field. The most significant feature of the field is its vertical centerline. As we view marks on the field we sense their force in relation to gravity, to the centerline and to the horizon. Everyone has experienced this strong force when looking at a picture hanging crooked.

Gradation. Gradation is a sequence of small steps or a blending from one extreme to another within a gamut, combining harmony and contrast. Dawn to dusk is a gradation of light intensities. Gradation may move in any direction. When it moves in all directions at once it is radiation.

Chapter One

Space

Curb Service
by Frank Webb
Watercolor
30" × 22"

Space is as important as
the objects. The objects
are used as visual step-
ping-stones of value that
cavort into middle dis-
tance.

Space, in this book, is neither a mark nor an idea,
but an essential subject of prestudy for the under-
standing of design. We live in actual space. A picture
has no actual space but only a flat surface. Upon this
surface we create virtual space — often called picto-
rial space, the picture plane, or the field. Through
our senses we instantly orient ourselves in actual
space; but orientation and creation of pictorial space
is originated by several artistic devices and con-
cepts. Space is the first creative act of any drawing
or painting, coming with the first mark scrawled on
the paper. The manner in which space is created is
one of the most telling characteristics of a painter's
style.

The picture plane is a physical object — a surface
with marks on it. Separately, these marks also indi-
cate another way to see the picture — as an illusion
of representational content. The picture as a physi-
cal object with graphic marks is the image that Rover
might see. What Rover cannot see is the representa-
tional content that might be there. With too much
representation, the work lacks artistic import. Give
too much attention to the physical surface and the
work becomes merely decorative. I favor combining
the physical and the illusion.

Flat vs. Deep

The images on ancient Greek vases, Byzantine mosaics and Egyptian paintings are almost totally flat. True, these wonderful works are decorative and certainly they gave visual identity to rich civilizations. At the other extreme the Old Masters, with the invention of light and shade in their art, began to focus almost entirely on bulk. These two modes are as different as pancakes and sausage. The trouble with the flat is that it tends to remain superficially decorative. And the trouble with too much rotundity is that the images burst forward while creating emptiness in negative areas. A better approach is to combine the flat and the deep. Deep because of the respect we have for reality, and flat because we must pay respect to a picture's essentially flat surface. As you study the paintings in this book you will see that while some are flatter than others, most combine the flat and the deep.

The Field

A visual image is a communication of experience, a creative act of forming. It has many of the characteristics of a living organism. It is always contextual, forming itself against a background or field (gestalt). Any visible unit on such a field generates spatial forces and sensations. These forces are the result of tensions between positions, sizes, shapes, values, colors and textures. The beholder reacts with neuromuscular responses as the parts organize into a whole.

Format

To design your picture choose the most expressive format. The most popular formats are: the horizontal rectangle, the vertical rectangle, the square, the oval and the circle. The subject itself usually suggests a format. A beach suggests a horizontal rectangle, while a standing human figure suggests a vertical rectangle.

Graphic Border

Many artists draw in a sketchbook, letting the edge of the paper be the edge of the design. It is far better to draw a borderline an inch or so inside the edge, taking care that the proportion matches your intended painting. By so doing, you will be more conscious of the composition. It is also easier to scribble values up to this border without the pencil getting caught at the edge of the paper or pad. The chief advantage of working up to a graphic border is that at the conceptual stage it effectively separates the picture from ordinary reality.

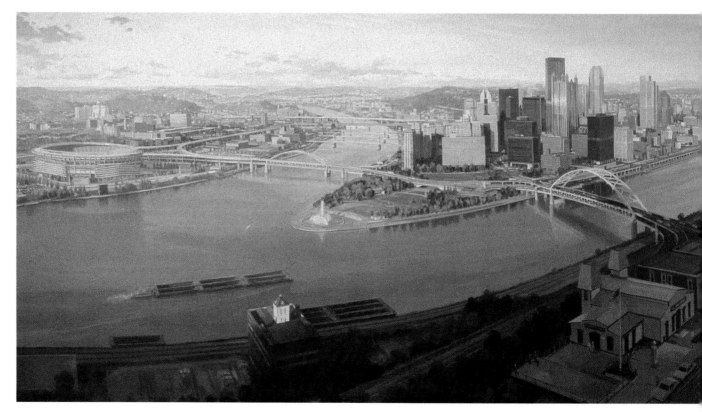

Opening the Picture

The first creation. It usually starts at the bottom moving inward and up. Next follows the main tension lines. The main movements may be lines, overlapping planes, or volumes. These first divisions of space require responses which become countermovements. This compositional approach is the opposite of rendering many forms and then cropping until it looks "good." Painting is an art of two dimensions. It is flat and will hang on a flat wall. It may indicate depth, but every movement into depth requires a return from depth.

Wisconsin Winter
by Randy Penner
Watercolor
21″ × 29″

See how we plummet down and into the middle distance by following the line of the road.

The Golden Triangle
© 1989 by Paul E. Rendel
Oil on panel
24″ × 60″

Pittsburgh's triangle wedges into a successful panorama. The quiet areas of rivers help us grasp the complexity.

Overlapping

There is no greater spatial sensation in a picture than overlapping. It immediately tells us which image is in front. You, the composer, need to *create* these overlaps for they do not simply lurk out there waiting to be noticed.

Space by Shifting. When overlapping lines are removed, a two-dimensional movement remains as an aftereffect of contours.

Diminishing of Sizes. If a part of a subject, such as a rock, is recognizable, any repeat of it as a smaller size suggests it has greater distance from the observer. You, the composer, should create these sizes as needed without relying strictly on sizes as seen in the subject.

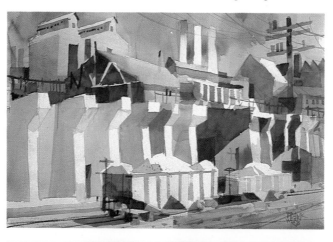

Planar Movements. Very powerful movements are created by planes which slant away from the flat picture plane.

A plane's spatial orientation comes from its position or from its relation to another plane and/or the picture plane. When one plane is close to the picture plane and another is more distant, there is a pull forward on the near one and a push back on the far one. As each movement into depth (push) is felt, another return out of depth (pull) is experienced. Volumes are made up of planes. To feel a plane one must envision an axis. The designer should avoid having a unit tumbling forward out of the picture plane.

Steelton Workshop
by Frank Webb
Watercolor
15″ × 22″

(Below.) Overlapping concrete piers define space. Monotony is avoided by making the fifth one darker and also by providing a huge tunnel.

Gills Rock
© 1992 by Ratindra K. Das
Watercolor
15″ × 22″

(Right.) Ratin has divided his paper well. The amateur adds and multiplies while the professional subtracts and divides.

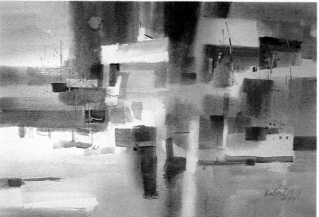

Sandy Youngblood
© 1988 by Nat Youngblood
Oil
28″ × 36″

Good contrasts of shape, value and direction are controlled by skillful use of shallow space.

The Edge of the Forest
by Frank Webb
Watercolor
15" × 22"

Most of this painting is negative space —
between tree trunks and between
branches.

Nearness. When people stand near each other, they are a crowd or group. When visual units are placed near to one another they comprise a configuration or a consolidated shape. If two units are shown in close proximity the space between is seen separately from the field.

Equivocal Space. In certain decorative or flat spatial concepts, overlapping, transparent shapes or lines foster equivocal spatial sensations.

Linear Perspective

Perspective helps the painter and the viewer understand what is seen. It indicates how to place fence posts that go back into depth; how to divide a plane into proportional units for windows; how to insert a dormer into a roof; how to convincingly suggest a looking down or a looking up. Perspective enables objects to seem to turn within the picture, and makes architectural shapes rest naturally on their base. Perspective can exaggerate warp, twist, or turn in any object so that people, animals or trees may be added and placed convincingly.

But strangely, some of the world's great art was produced before the Italians invented perspective. Its use today is somewhat ambiguous, becoming both a hindrance and a blessing. There are times to downplay perspective and times to forget it, but there is a big difference between forgetting it and never having understood it. Perspective needs to be mastered to avoid its tyrannical manner of dictating the sizes and positions of images. Linear perspective requires a single station point. At that point the single eye of the beholder becomes the center of the whole world. The most popular linear perspective uses two vanishing points placed on the horizon line, one beyond the picture at left, and the other beyond the picture at right.

Planes then vanish to these points, left and right. A thorough knowledge of linear perspective is essential for it is one of several ways to make depth. Mastering perspective helps one to draw relationally.

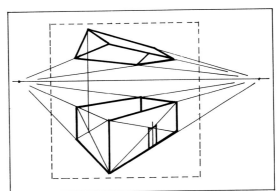

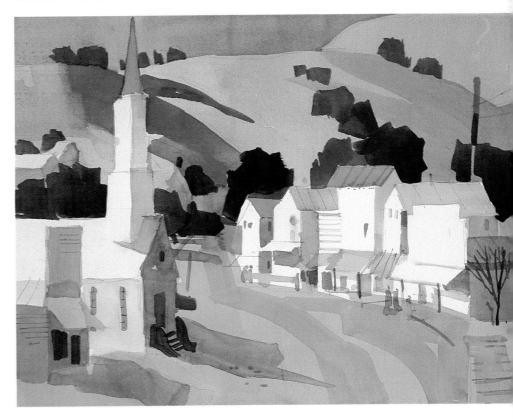

Sutter Creek
by Frank Webb
Watercolor
15" × 22"

Overlapping, diminishing sizes, and converging lines take us into pictorial depth, but we are contained effectively by the hillside.

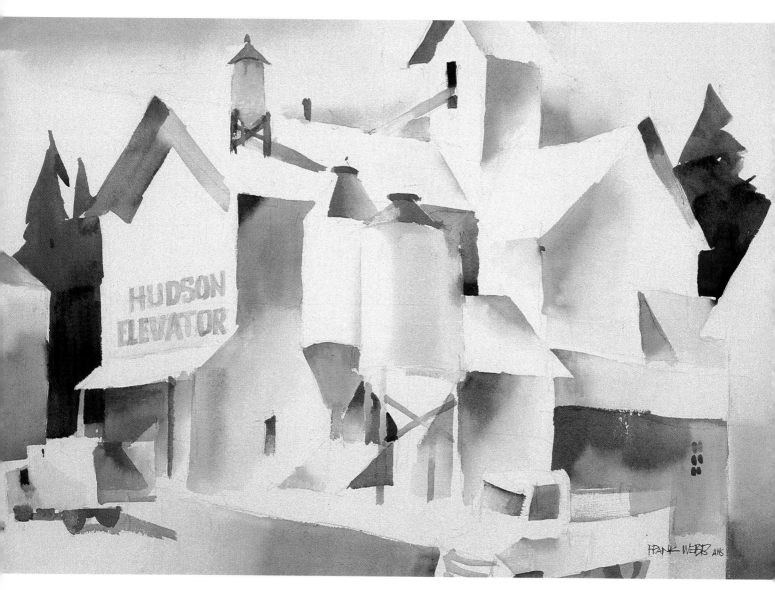

Hudson Elevator East
by Frank Webb
Watercolor
15" × 22"

Spatial sensations dominate this work as
value gradations push back space.

Parallel Perspective

Also known as sectional perspective or single point perspective, parallel perspective shows the object with its chief plane parallel to the picture plane. No matter how far back it goes, the object keeps this same position and proportion (differing from linear perspective where there is a change in shape as well as size).

Chinese art exemplifies parallel perspective and also uses isometric projection. In isometric projection all movements into depth are made at the same angle. They do not converge as they do in linear perspective.

Depth by Position. It is always assumed that the top of a picture is farther away and the bottom is nearer because of the reference to a ground plane.

Three Stages of Depth. A very powerful spatial effect results when a landscape is conceived in three stages: the foreground, the middle ground, and the far ground. It is the contrast between these three that does the job. Cézanne used this technique effectively, while suppressing linear perspective in the foreground.

Spatial Effect of Color. Most painters feel that warm colors advance and cool colors recede as one beholds them in the picture. Their most convincing argument is that blue recedes because of its association with the infinity of a blue sky. A weak spatial device, color is immediately eclipsed by any stronger spatial sign such as overlapping, diminishing sizes, and perspective.

Negative Space. Sometimes called negative shapes, negative space is unoccupied space. The creative artist shapes and plans these spaces or areas with as much care as positive space. In literature negative space is the poetry of the unsaid, in music it is the rests.

A wonderful nothing is space,
Where everything may have a place.
Resisted rotundity
Expresses profundity
And flatness shows your good taste.
 —Frank Webb

Demonstration ■ Dean Mitchell
Breaking Up Space

Dean is very definite about defining space. This young professional realizes that the most challenging aim of creative painting is to combine realism with good abstract structure. His career started with oils but he now works in various media. Each work dictates its own special sequence of operations—some works proceed initially with darks and others with middle values. Dean often plans the design with thumbnail roughs made on location. When working from photographs he prefers black-and-white prints. They allow him to discover a more personal color.

This demonstration, *Shipyard*, is painted on watercolor board. My reaction to this painting is a sense of the space moving into the middle distance. Its several stripes initiate good negative spaces—a sort of industrial lace. Dean does not choose his subject because it will sell. He paints it because he enjoys its possibilities.

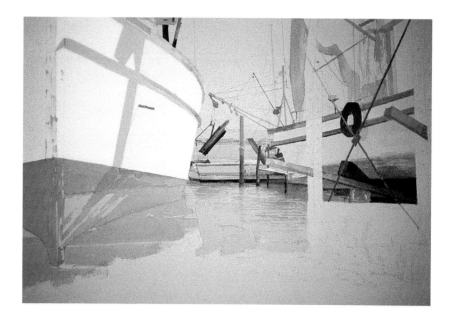

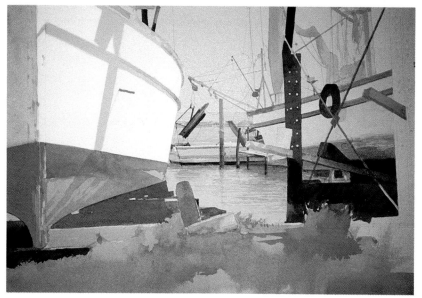

Shipyard
by Dean Mitchell
Watercolor
7½″ × 10″

Step 1
Dean defines space through values, edges and size relationships.

Step 2
The variety of forms, complex angles and overlapping planes creates a playful linear energy.

Step 3
The foreground is simple—it defines weight in the composition and puts you solidly in the space through value, mass and edge.

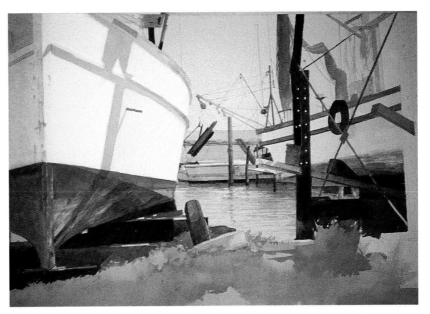

Step 4
Space is divided decoratively by intersecting lines and rigging.

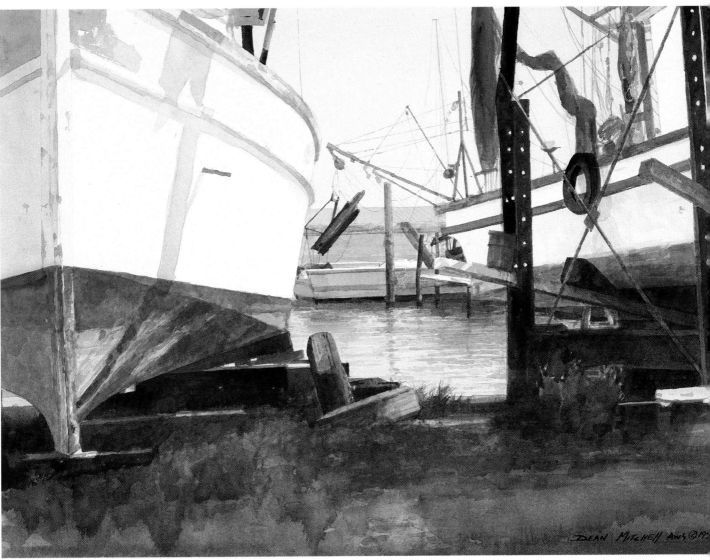

Demonstration ■ Frank Webb

Flatness by Layering

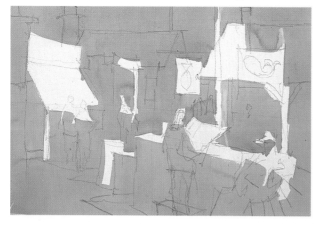

Step 1

The mother-wash is Hansa yellow with a touch of sepia. It is applied flat, leaving hard edges around planned whites. I blast it with a hair dryer.

Step 2

The second wash is made of alizarin crimson plus a little Payne's gray. Its color is seen only where it covers white areas. Elsewhere this plum color takes on a kind of russet where it crosses yellow.

I am so fond of combining the flat with the deep that I often paint in flat, hard-edged, transparent layers using continuous tonal values. In such a painting I deliberately avoid gradations, keeping all edges hard. The first wash is the mother-wash. It establishes not only the high mid-value but the color dominance. The mother-wash is usually made of my most transparent paints (lakes, such as alizarin, phthalo blue, and gamboge).

This painting started with a wash of Hansa yellow darkened a bit with sepia. The aim of this exercise is to create space with flat washes. The discipline of the insistent flatness forces me to rely on value shapes. A bonus comes with exciting optical color resulting from colors showing through other colors. Because the superimposed washes are painted only on dried washes, the colors do not literally mix—they are *perceived* as a mixture because of watercolor's transparency.

Of course this effect can be achieved only with transparent media. It is offered not as a way to paint, but as a way to study painting. It is primarily a shape-spatial study. If your works take on the look of "pretty pictures," you might try one of these. I recommend using rough paper. The reason is that the washes are so flat—devoid of color variations and value nuances—that the surface texture of rough paper helps to add interest. Whistler used very rough canvas for the same reason; his tonal values were simple and broad.

I believe that I have learned more by broadening my experience. There is a time to paint flat, and a time to paint deep; a time for watercolor, and a time for oil; a time for wet, and a time for dry; a time for realism, and a time for abstractionism. There is no one way to paint even for one person. There is only constant study and playing with options—otherwise we live the dull life of a machine.

Notes on Transparency

Most artists' paints are made of small particles of pigment mixed with a vehicle such as linseed oil or gum arabic. Other paints are made of soluble dyes. Technically, they are called *lakes*. Some watercolor painters refer to these as staining colors. These lakes are the most transparent in watercolor. The easiest way to identify them is to memorize the most popular ones: alizarin crimson, gamboge, Hansa lemon, phthalo blue, phthalo green and any of the Acra reds. Also, any paint with the name "Winsor" in front of it, such as Winsor red. The difference between a lake and pigmented paint is especially noticeable in purist watercolor practice. In other opaque media a paint made with a dye or toner is less distinct since it is usually combined with other tones made of opaque body color.

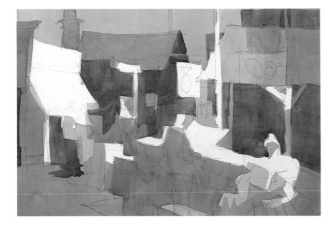

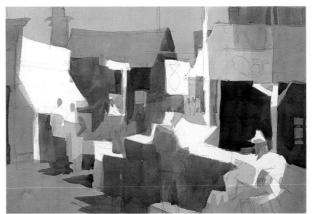

Step 3
Again the paper is dried. Now I run a wash of green to darken the vertical planes and also to add color interest.

Step 4
Darker purples and details begin to emerge. For me this stage is always exciting.

Step 5
The usual watercolor endings are applied: calligraphy, small dark accents and textures.

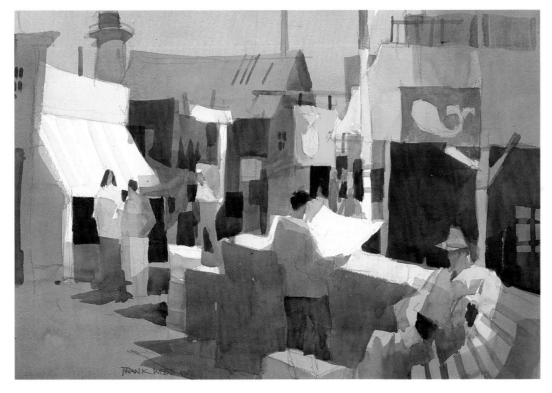

Monterey Morning
by Frank Webb
Watercolor
15" × 22"

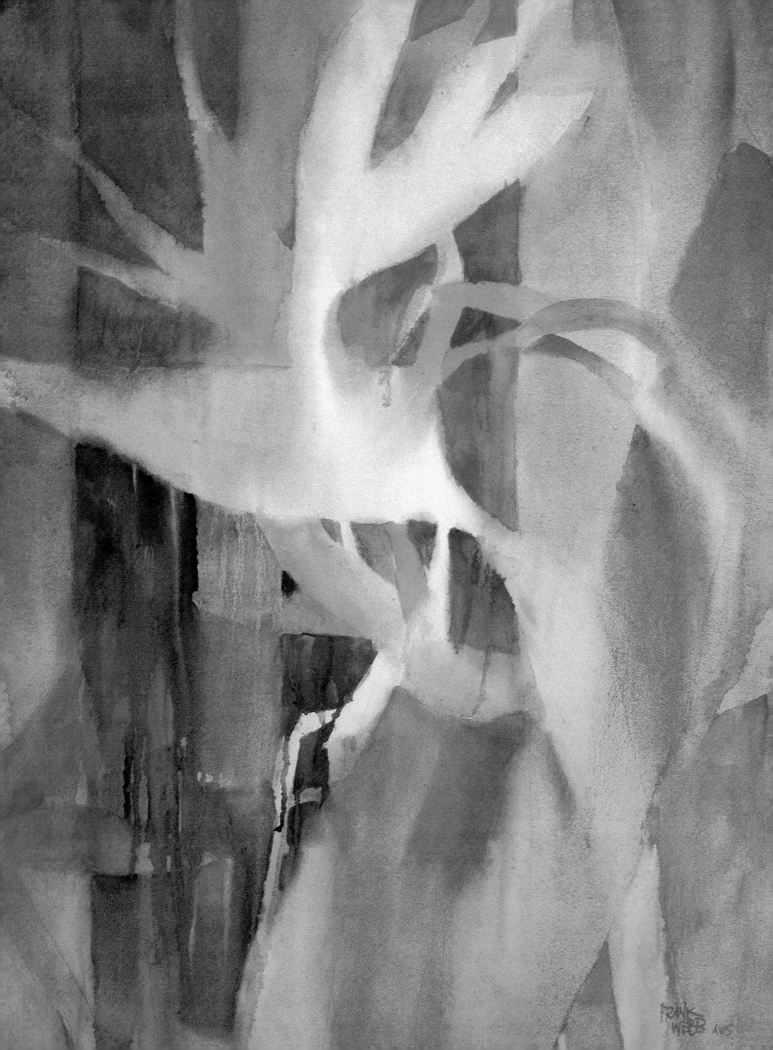

Chapter Two

Ideas

Bird of Paradise
by Frank Webb
Watercolor
30″ × 22″
Collection of Mr. & Mrs.
Stephen Szabo

A vertical format and direction were established, and white shapes and other values were imagined. I did not paint a flower, I painted my idea.

Beyond expressive communication, the single most important quality in art is unity. Unity is not found by looking through a viewfinder and making a passive copy of visual data. It must be created by a deliberate bonding of parts in relation to the whole. Unity is a selective re-creation of visual images. All parts must be modified and all alien ideas and extraneous images must be negated.

The raw material of your subject must be re-created just as the musician must bring forth music from an instrument. Pictures are like living bodies. Though all the parts of the body have a different function, all are important to the well-being of the whole. And as all body parts are under the direction of the heart and the head, so too, the heart and the head should rule the picture. Unity results from the harmony of closely linked symbols, ideas or objects. Unity can be static, as in a snowflake, or it can be dynamic, resulting from movements. Unity emerges from style, technique and personality. There is not another Van Gogh nor is there another *you.*

Unity can be achieved by providing dominance between the various conflicting elements. The following compositional ideas, especially the next two, are closely linked in the search for unity.

Contrast

Contrast is opposition, conflict, or complementarity. The presence of contrast creates interest. It can be violent or mild. Contrast is a sovereign principle in any style. It is the plot in fiction. Little or no contrast is boring. Too much contrast is chaotic and confused.

A visual work of art is primarily an organization of contrasts. Typical contrasts include: dark vs. light, near vs. far, smooth vs. rough, fat vs. thin, high vs. low, eventful vs. noneventful, bright vs. dull, etc. Matisse agrees, "I do not paint things, I paint only the difference between things." Easily bored, we seek the play of opposing forces. The eye always goes toward contrast. Gather together minor contrasts and play large contrasts against each other. As contrasting elements grapple and clash, prevent anarchy by establishing dominance between the various conflicting elements. This restores unity by not allowing any part to become too attractive.

Since the eye is always attracted to contrast, the designer can initiate a center of interest, thus avoiding optical democracy. Marks of greatest contrast should not be placed near the border but somewhere inside near the heart of the painting.

CONTRAST DOMINANCE

Line

Shape

Value

Color

Texture

Size

Direction

Dominance

Dominance means to rule by superior force. It is achieved by subordination of a competitor. Dominance resolves contrast, producing unity. Dominance is character.

Typical dominances are: the horizontal directional dominance of a beach, the soft textural dominance of a cloud, the dark value dominance of a night scene. Dominance of value, color and texture is achieved by size and also by repetition, resulting in accumulated size. If the largest area is occupied by blue, you have a blue dominance. A directional dominance is established by the direction that is most repeated. A line dominance is either curved or straight, whichever kind of line is used most.

Melodramatic violence and even discord may be held and unified in a scheme provided that dominance is employed. We see, we unify and we judge by dominance.

Penfield Barn
by Frank Webb
Watercolor
15″ × 22″
Collection of Christopher Webb

(Above.) My dominant size here is the barn; dominant color, warm; dominant direction, slanted; and dominant value, middle.

Steam Fitters
by Frank Webb
Watercolor
22″ × 30″

(Below.) The following dominances unify this painting: direction: horizontal; size: locomotive; line: straights; color: yellow-green.

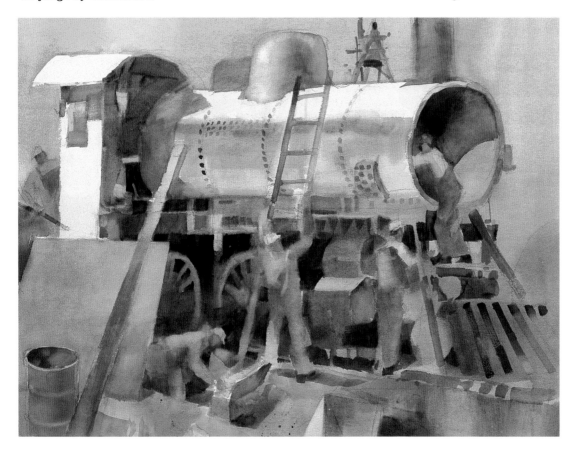

Repetition

Repetition may be either exact or varied. The designer may repeat hues, shapes, values, colors, textures, sizes and direction. Echoes and resemblances pull the work together giving it a visual theme.

Repetition occurs in the seasons, and in the ebb and flow of the tide, etc. Repetition differs from harmony. Repetition is an identical relationship; harmony is a similarity. Alternation is a variation of repetition. It is used to animate the picture by causing elements to shift, setting up a pulsation. Repetition may be used with any of the seven marks. Since exact repetition is boring, the designer must use variations. The stature of the composer is revealed by the degree of wit used in making variations.

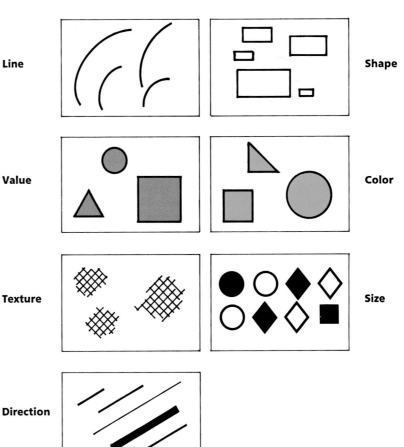

Line

Shape

Value

Color

Texture

Size

Direction

Sunshine Series #42
by Linda A. Doll
Watercolor
14″ × 20″
Collection of Barbara and Frank Webb

(Left.) Linda uses repetition with variety. Left to right: Barbara Nechis, Frank Webb and Barbara Webb.

Snow Fields
by Frank Webb
Watercolor
15″ × 22″

(Right.) Rhythm is re-created in fluid brushstrokes in the immediacy of fast, direct painting and a close harmony of cool colors.

Rhythm

Rhythm is a repeating beat in which no two elements are identical. In music, rhythm is felt in the flow and in the intervals (rests) of time. An extended interval causes suspense. In the spatial arts, intervals allow us to create rhythm. Rhythm is utilized in contour drawing when the line is picked up and continued even through the interrupting objects. Repetition and rhythm create bonds among parts while alternation adds interest.

Town Church
by Dean Mitchell
Watercolor
20″ × 15″

(Right.) Daylight itself provides a certain rhythm in shadow shapes, especially when the light falls at an angle.

Harmony

When art elements have similar attributes they are harmonious. Harmony takes place between the extremes of boredom and chaos, combining stability with change. Units with closer likenesses are harmonious while extreme contrast moves toward discord.

When images are psychologically or aesthetically associated they are harmonious; for example, bread and wine, hammer and anvil, truth and beauty. Same size marks of spectrum red and spectrum green (intense red and intense green) have a harmony of value even though they are a disunity. To achieve unity one of them should be larger, less intense, or the color contrast changed to blue and purple or green and blue. Harmony results not only from similarities among art elements but from similarity of intervals.

This photo of the barn in the painting at right shows the unrelatedness of a red barn surrounded by green. The painting is based on an on-the-spot sketch.

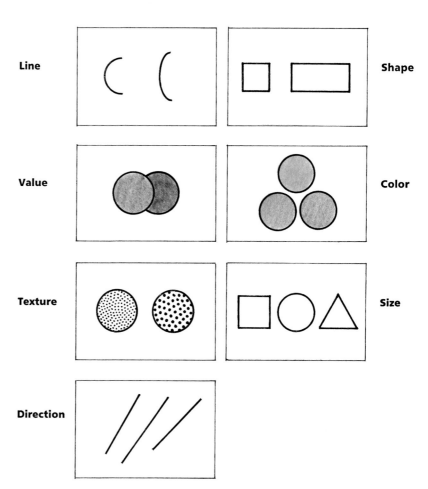

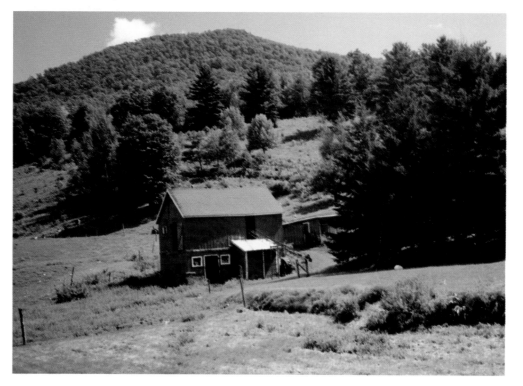

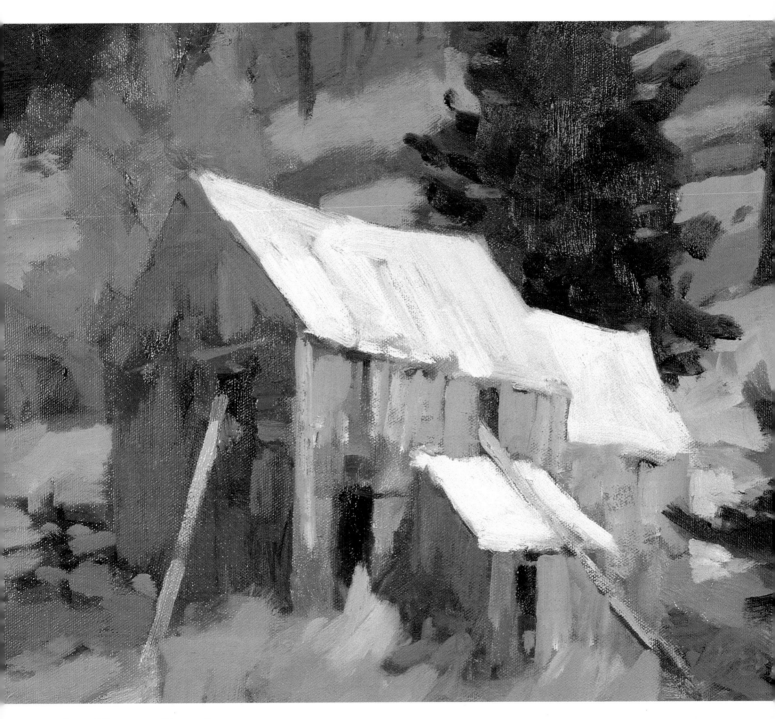

Barn at Evergreen, Vermont
by Frank Webb
Oil
11" × 14"

Typically, I solve the problem by having one color dominate the other, or by placing greens into the reds, or reds into the greens.

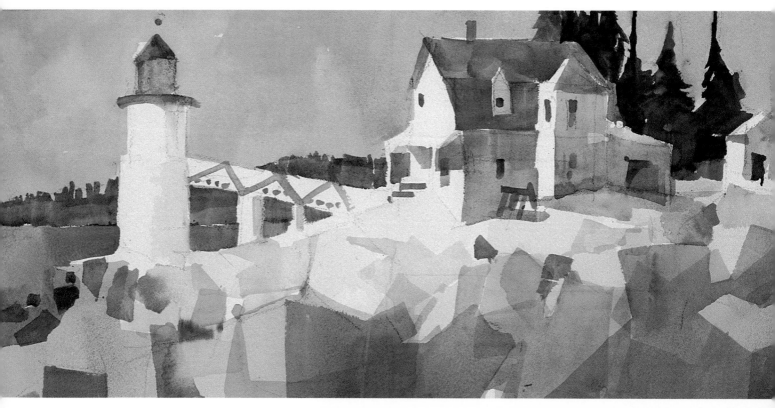

Marshall Light
by Frank Webb
Watercolor
16″ × 30″

(Above.) Although painted in arbitrary color patches, there is harmony here by sheer association: lighthouse, rocks, ocean, sky and pine trees.

Old Forge Hermitage
by Frank Webb
Watercolor
15″ × 22″

(Right.) Straight lines are echoed throughout, houses are turned to suit my purposes, colors are pulled together by common washes. The hermit built his own town; I built my own harmony.

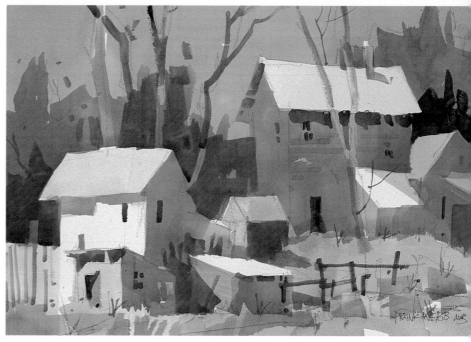

Balance

Opposing visual forces must be balanced. Marks are not only seen but must be *felt* as forces within the pictorial field. The most significant feature of the field is its vertical centerline. As we view marks on the field we sense their force in relation to gravity, the centerline and the horizon. Everyone has experienced this strong sense of force when looking at a picture hanging crooked.

There are two kinds of balance, symmetrical and asymmetrical (formal and informal). Symmetrical balance is achieved when marks of the same weight are placed at the same distance and position on both sides of the pictorial field. Asymmetrical balance is achieved when unequal marks are balanced by placement in different locations left and right.

A single mark centered on the field is dead. If it is moved to one side it lives but is unbalanced. A similar mark placed on the other side restores balance but has low vitality. This is an example of symmetrical balance.

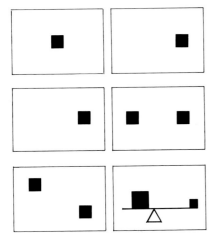

More interest emerges from asymmetrical balance. Here marks vary in position, though balanced by equal distance from the center. The most dynamic balance of all is asymmetry achieved by marks of contrasting line, shape, value, color, texture, size and direction. Typically, asymmetry results when a smaller mark is placed at a greater distance from the centerline while a larger one is closer to center. Asymmetry is often illustrated by a steelyard or a fulcrum. The larger mark must be placed closer to the fulcrum to balance a smaller more distant mark. This idea is usually demonstrated when children of different weights balance on a seesaw.

Marks must be weighted and placed by feeling. No scientific apparatus can substitute for the painter's intuitive eye. Isolated marks weigh more than crowded ones. Marks nearer the border also weigh more. Human interest weighs more than a larger nonhuman mass. A graded area or shape carries more weight than a flat one. A busy area weighs more than an empty area.

Balance is not the end-all of art. But without balance the work is seriously stunted and has little life expectancy.

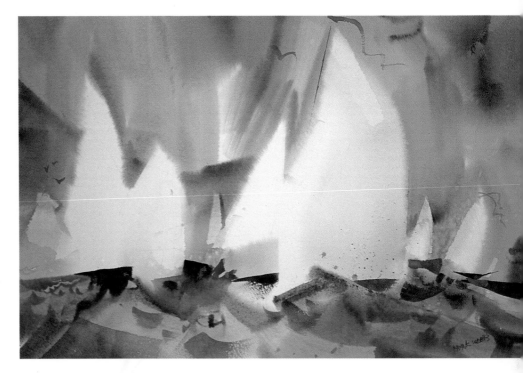

Sail Ho Ho!
by Frank Webb
Watercolor
15" × 22"

One paints by balancing unequals. Here is a piece of warm. One feels the need for another somewhere. But where? I can't measure its location; it must be felt.

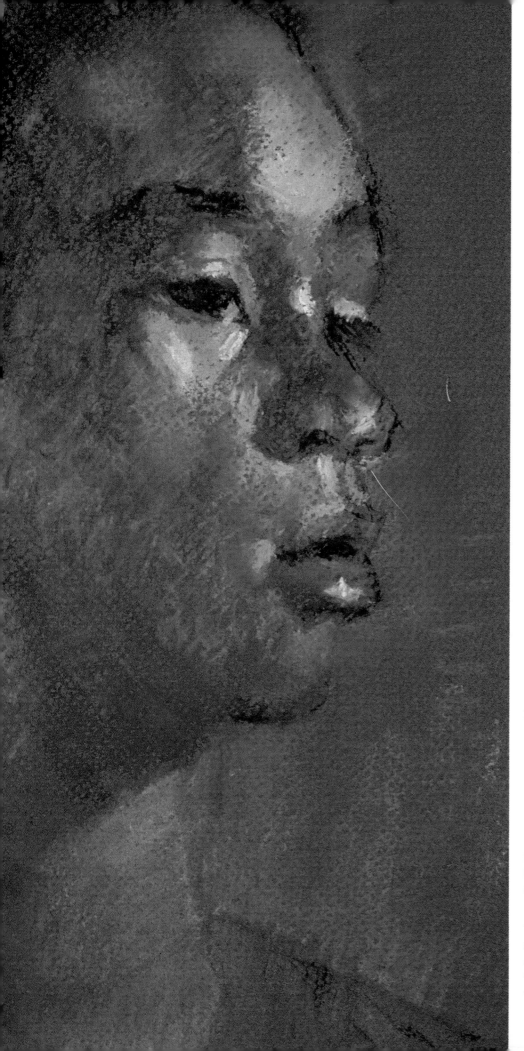

Gradation

Gradation is a sequence of small steps or a blending from one extreme to another within a gamut, combining harmony and contrast. Dawn to dusk is a gradation of light intensities. Gradation may move in any direction. When it moves in all directions at once it is radiation.

Gradation is a valid concept, just as the other six compositional ideas discussed in this chapter are valid, because it is psychobiologically true. These seven ideas spring from life. They are not merely a gang of rules thought up by cloistered academicians. Gradation suggests the movement of time in a space continuum. For example, a graded sky seems to imply the moving of the sun. Gradation is the easiest and most economical means to make a large area more lively without adding another object (the rule of parsimony). Gradation is effectively used with all seven marks. When rendering tubular or spherical objects, gradation of values expresses curving surfaces.

In the theater, gradation of light produces mood and accent and purposefully avoids monotony. One of our six value plans shown in chapter five is gradation across the entire field. The compositional ideas of this chapter are further exemplified in the paintings shown in chapters three to nine.

Reverie
by Frank Webb
Pastel
12" × 5"

There are at least three uses of natural gradation here. Values run from dark to light, colors blend from one to another, and intensities grade from bright to dull and vice versa.

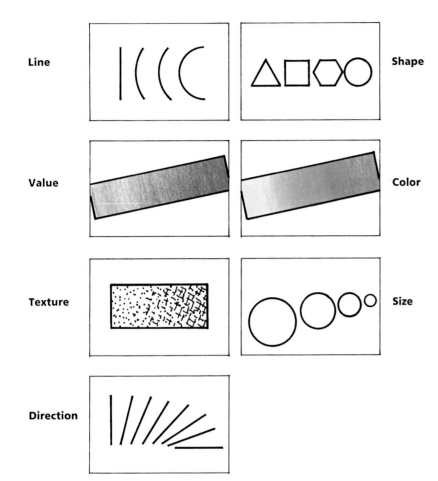

Line

Shape

Value

Color

Texture

Size

Direction

Making Your Marks

Compositional ideas and spatial concepts will be paraded in a galaxy of professional paintings. These pictures are not merely painted—they are *built* with ideas and graphic marks. Plato said that, "By means of art we build another kind of house—a kind of man-made dream produced for those who are awake."

When does a picture or a decoration become art? When it deliberately apprehends beauty. Since beauty emerges from the relationships of the parts to the whole, we are in the composing business. Critique any painting in this book. You will find it displays both faults and virtues. More importantly, critique your own paintings to see if these compositional ideas are present.

Spontaneous me, I do declare,

That glitches turn up everywhere.

I seek in vain for useful parts,

Among my paintings labeled

 "starts."

 —Frank Webb

Tips

● Unless *you* are excited about it, how in the world can you expect *me* to get excited about it?

● Avoid the trite, the visual cliché. As Matisse said, "Ready-made images are for the eye what prejudices are for the mind."

● Do not have anything in your picture that doesn't explain itself.

● Your picture must be nurtured by compositional ideas with the same attention that you nurture your own physical body.

● It is better to deal with compositional problems at the outset than face the finished picture as an embalmer.

● Shrug off the tyranny of the subject or the photo and use all five senses plus your memory.

● Don't be distracted by new ideas as you go along. Stick to your concept.

● Why rely on the eye alone? Paint how it *feels* to you. Your emotional tone transforms parts.

● The most common reasons for poor work are: bad shapes, scattered or wimpy values, and no size dominance.

● "An orgy of self-expression is no more productive than blind obedience to rules." —Rudolf Arnheim

● We do not create things. We create relationships.

● A drawing badly started takes on the same misbegotten authority as a false printed word.

● "Sometimes a thing which seemed very 'thingish' inside you is quite different when it gets out into the open and has other people looking at it." —A.A. Milne

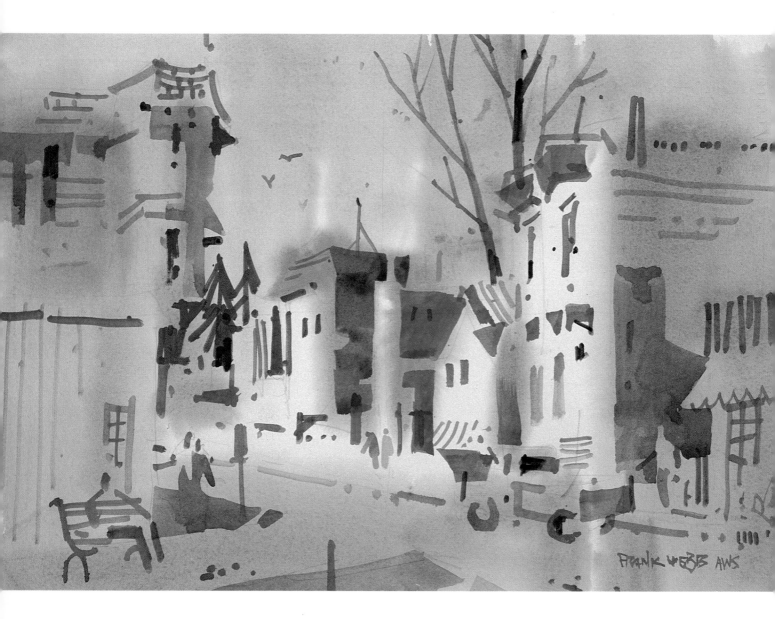

Chapter Three

Line

Ferndale
by Frank Webb
Watercolor
15" × 22"

Calligraphy perfectly expresses the California town noted for its Victorian buildings. I augment my line with soft, wet-into-wet, out-of-focus washes.

Art is like morality, it's where you draw the line. Line is the path of action—the path made visible. With the exception of the dot it is the simplest of graphic marks. We think, plan, plot, write, map and doodle with linear gropings. Of all marks, line is the most direct; any pencil will suffice to create it. Decisiveness and economy make it a universal language. The child says, "I think and then I put a line around my think."

Lines function as divisions among shapes, values, other lines, intensities and textures. Line may be line for its own sake, as in calligraphy. In its calligraphic use, line (1) ties areas together, (2) enlivens dead areas of a painting, (3) serves as symbols. Symbols include letter forms and numerals plus any sign or mark that infers a thing. Because the eye follows line it becomes part of the composer's strategy. An implied line is seen when objects are lined up in a direction. Line is inferred when the mind fills in between points, as in heavenly constellations (closure).

Precise lines are made by mechanical instruments, but ofttimes we enjoy a sensuous freehand line with wonderful irregularities, selective emphasis and rhythms. Lines can be the very sign of life.

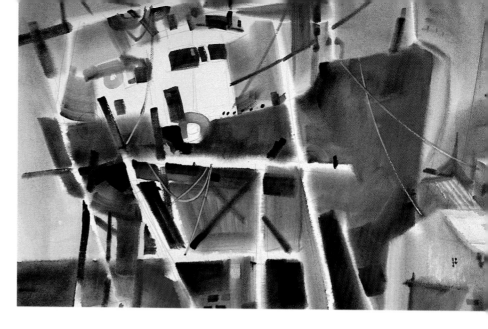

Line as Design

Parallel lines, cross-hatching and stipple can be used to build tonal values and textures. Thus line is so versatile that it can serve almost all picture-making, even the use of color. Lines may be short or long, fat or thin, flat or deep, soft or hard, continuous or broken. Cézanne and Van Gogh used broken or segmented lines to merge a figure with negative space. Sometimes we are as much aware of the absence of line as we are of its presence. Matisse advised, "One must always search for the desire of the line, when it wishes to enter or when to die away."

We all plan and draw in line. Line as line is potentially beautiful and most expressive. Lines make drawings, but paintings are made of shapes, not lines. Shapes are made of values, colors and textures. Shapes are bounded by line if we think of line as edge. When we focus on line as edge it has only one quality which concerns us—straight vs. curved. It takes both to make an exciting scheme. "A line cannot exist alone: It always brings a companion along." —Henri Matisse

Boothbay Ways
by Frank Webb
Watercolor
22" × 30"

(Above.) Straight lines of grille fracture the picture plane, adding a spatial sensation and a decorative surface.

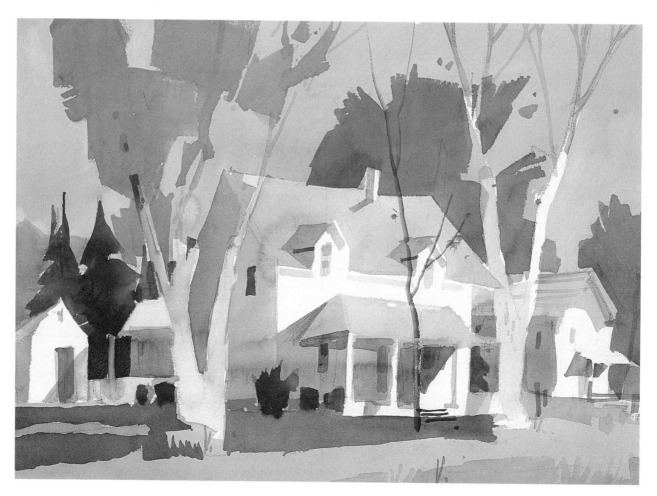

Tulsa Neighborhood
by Frank Webb
Watercolor
15″ × 22″

(Left.) This was painted in flat, superimposed layers. Because the subject is houses, I have echoed house shapes on the foliage; that is, straight lines and angles.

Straight Line

A straight line is precise, hard, masculine and economical. There are few straight lines in nature, they are man-made. If we were limited to a choice of straight or curved, the straight would be the better choice, since curves may be suggested with a series of straights. When straights are used as a series of angles to turn a curving contour, the exact point of the most telling curve may be shown, whereas it is difficult on a curved contour to show the most pertinent location of a change of direction. A line may be zigzagged to express great energy as in a bolt of lightning.

Above Market Square
by Frank Webb
Acrylic, transparent and opaque
28″ × 32″

(Above.) Entirely made of straight lines, variety here is achieved by directions, with emphasis on the slanting.

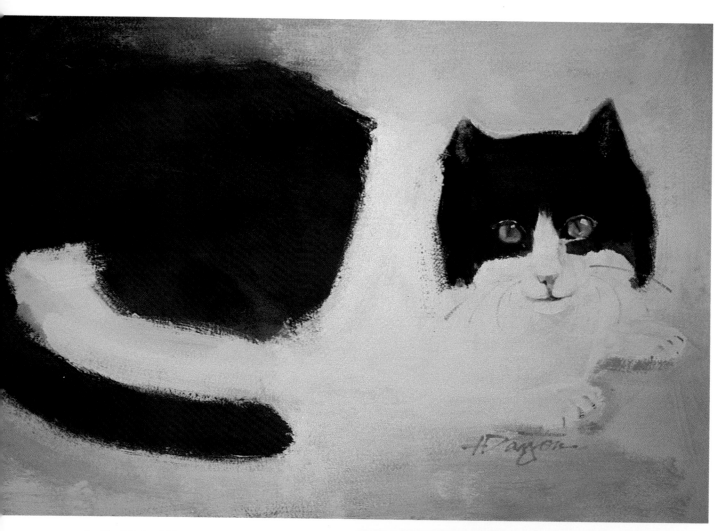

Le Chat Noir et Blanc
© 1991 by Harry Dayton
Casein
15″ × 22″
Collection of Susan Hadden

(Above.) The line here is definitely curved, but notice that curves are relieved by relative straights.

Hey Bernie, How Much for the Bananas?
© 1990 by Judith Blain
Watercolor
18″ × 24″
Private collection

(Right.) Curves help to unify bird, bananas and broadleaf. The whole vignette makes a great shape against the white paper.

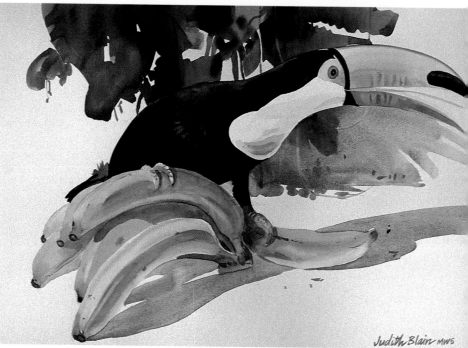

Curved Line

A curved line becomes exciting when positioned near a straight, and vice versa. A line curving in both positive and negative directions is a compound curve. Loose curves are feminine while tightly curved lines are active and powerful. When a line gradually changes direction it is a curve; when it changes suddenly it is an angle. Excessive curves were used in Baroque art of the eighteenth century and Art Nouveau of the late nineteenth century. Many of these examples appear to us to have a sense of life, although some are flabby and irresolute.

Abstracted Stew
by Ann Templeton
Oil
16″ × 16″

Great variety in the overall shape is made by value linkage, which simultaneously creates the great negative shapes of the background.

Arabesque

One of the most exciting curved lines is the arabesque. It is a symmetrically undulating line that culminates in an energetic, whiplike movement. The arabesque is especially effective as a way to activate a square format. It may be initiated as an actual line, an implied line or sequence of colors, values or textures.

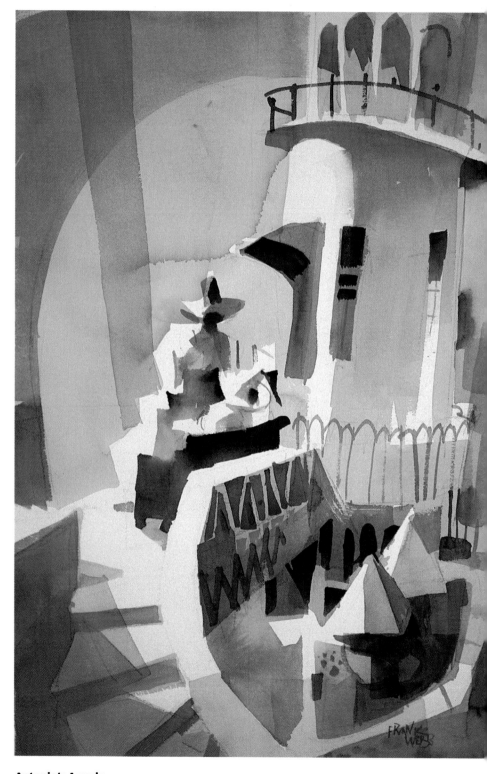

Antonio's Arcade
by Frank Webb
Watercolor
22" × 15"

The arabesque need not be as blatant as this. A more subtle one can be made of pieces of color or value.

Unity

Unity of line results from playing the straight against the curved, with one being dominant. Unity by repetition is achieved by repeating directions, measure, or position. Line is harmonious when similarities of directions, measures, and positions are established. Balance of line is felt as an equilibrium relative to the picture's vertical axis. Gradation of line may be from straight to curved, vertical to horizontal or short to long.

Parallel lines on a plane suggest a flow of light. For instance, consider Leonardo, who was left-handed. His parallel shading lines made with the left hand run from northwest to southeast. Right-handed masters made southwesterly lines to indicate shade.

Tips

• Break lines into different measures—some short, some middle-sized, and some long. On curves use different size radii—some slow curves and some fast ones.

• Think of lines not as the edges of objects but as the boundaries of two value shapes.

• Avoid tangents. Instead make a decisive overlap. Stop and detour any line straying to a corner. Use lines to slow up or stop other main lines that are approaching the picture border.

• Is a contour line really needed at a value edge? Avoid line when color-value shapes read clearly.

• If you have a ragged or sawtooth line, oppose it with a simple, uneventful line. For example, the far shoreline of a lake is straight and simple, whereas the near shoreline is full of incident.

• Relate line (edge) to value. Flat values are best expressed with straight line. Highly modeled value shapes, like clouds, call for undulating contour.

• Always have one longest line whether straight or curved. It adds backbone.

• Create junction at the center of interest. Use lines to lead the eye there.

The minimalist line is thin and dry;

But more because it's less.

There's less to it than meets the eye—

Most certainly true, I guess.

—Frank Webb

• If your scheme is mostly curves, introduce some straights, not only for variety's sake, but also to relate to the border.

• Scribble gestures. Feel the action of the opposing directions. Visualize the hidden linear axis in every volume you draw.

• On a complex volume such as a human head, use line to emphasize key points. These are points of most importance, where planes come together, such as the separation between the lips, the corners of the eyes, the corners of the mouth, the base of the nose, the hairline, the widest point on the cheek, the bottom of the chin, the brow, etc. Line is used for exploration, construction and expression. (See the demonstration on the next two pages.)

• Any long line (edge) should have incident enroute. A value, color, crossline or other interrupter should be provided to create pause or relief and to integrate the long line. This incident generally will be a value change, color change, or line which passes behind the long line at a good place; not at the center and not too near one end.

• Sense your border lines as you put down other lines. They affect the lines of your subject.

Demonstration ■ Angelo Di Vincenzo
Constructing a Head With Key Points

Now retired, Mr. "D" is one of my favorite teachers. He taught that lines on a drawing are only temporary boundaries within which to place tonal values. Notice in the drawings on these two pages that he is using straight lines for blocking in shapes. It helps you to compare shapes. His drawing begins with a study of the head and its most obvious points: the top of the head, chin, hairline, eyebrows, corners of eyes, base of the nose, corners of the mouth and the widest parts of both cheekbones. At these points all measurements or comparisons should be made. Because a portrait requires exact proportions, these key points eliminate guessing and help to keep your drawing correct through all stages regardless of the movement of the model or the thickness of paint. It is good to restate these points from time to time as the painting progresses. Each figure or form has its own set of outside contours and inside patterns and they must fit together. Establish the large simple forms first, then the next largest within and so on. The shading is visualized initially in only two tones so that detailed variations will not be confusing.

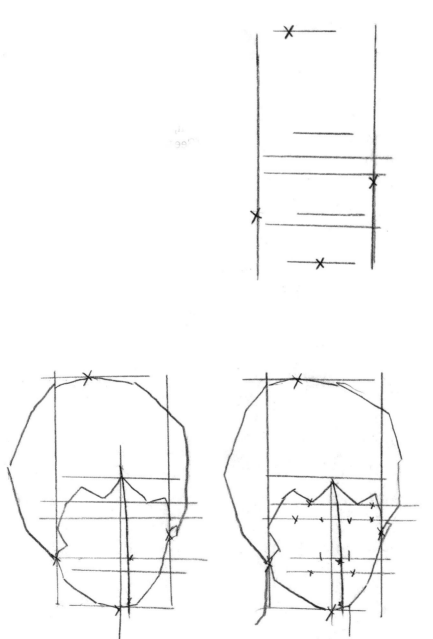

Step 1
Establish the top of the head and the chin; usually halfway between these are the eyes. Next comes the hairline followed by the noseline and the corners of the mouth (about halfway between nose and chin). Next comes the width between cheekbones, as compared to other distances. The four extremities are marked with an *x*.

Step 2
Study the directions of angles from key points. Compare them to the vertical lines. The box relates to the face only. The hair and ears are added later. Drop a vertical line from the center of the forehead. If the head is tilted, place a slightly curved line in relation to the vertical. This identifies the centerline of the features.

Step 3
Compare the width of the eyes plus the interval between, and the space at each side. Place an *x* at each of these points and also one at the topmost of the brow. Compare the nose width to the eye width and the corners of the mouth to the nose and eyes.

Step 4

Look for the shadow edges. If they are not distinct, squint your eyes and try to see solid shapes. Compare all these to your key points.

Step 5

Stroke in the shadow shapes with a mid-value. This begins to indicate the three-dimensional quality of your drawing.

Step 6

Now look for the variations within the shadows. Some of these are local values, such as hair; others are due to accents and modeling.

Step 7

The final stage includes the addition of halftones. These are made of light over-lapping strokes at the edges of shade. Accents are considered, edges are carefully adjusted. Shade lines in this drawing are vertical, suggesting a light source from above.

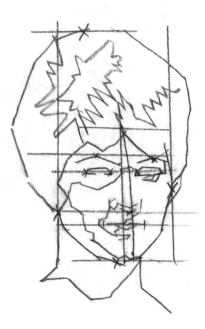

Demonstration ■ Charles Movalli
Curves and Angles

Charles Movalli's own words show his devotion to curves vs. straight angles:

"The *subject* of a picture is both its most important and least important element. Something in the scene holds us and piques our curiosity. But that something must be analyzed; we can't let the fact distract us so that we forget the *set of relationships* that drew us to the subject in the first place.

What attracted me to this Gloucester harbor scene was the way the crowded boats form a set of interlocking angles, relieved by the sweep of a few gracefully curved bows. These curves enliven and thus emphasize the angles. All other distracting elements are eliminated. For example, there is practically no sky, little foreground, and no water."

Gloucester Harbor
by Charles Movalli
Oil on canvas
16" × 20"

Step 1
Segments of line are contrasted by direction and also by straight vs. curved.

Step 2
Shadows change quickly outdoors so lights and darks are put in first. The darks emphasize the all-important angles and curves. This relationship should, if anything, be exaggerated—statements of fact don't catch the viewer's attention. The darks also establish the rhythmical pattern of the picture: You can turn it upside down and still have an interesting design. Although the scheme is basically flat, with a very shallow pictorial space, some depth is created by changes in scale.

With the light-and-dark pattern set, I can work anywhere on the canvas, in any sequence I like. I'm interested in how the picture fits the canvas, how it works as a posterlike pattern—so I work all over the place. Warm colors are a good place to begin: The lay-in has already distributed some of the darker, cooler notes. The warm colors are placed in a balanced way. But don't overdo it! The picture will become static. That's a danger facing all pictures. A lively design can be killed by the act of painting it! Some strong, symmetrical bias within us is determined to *tame* the picture surface.

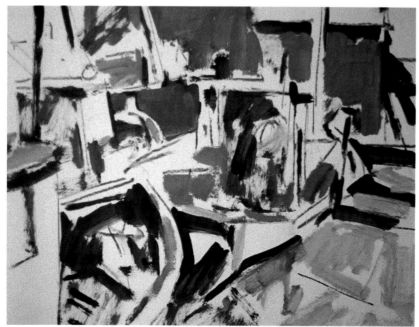

Step 3

Now the lighter cool colors are distributed over the surface. The picture is composed not only of angles and curves, but also of warms and cools. Each explains the other through contrast: You never know your opinion as well as when someone contradicts you. At this stage, the picture has a life that is sometimes lost in the final work. It's a turn of events that exasperates the painter and makes him or her ponder long and hard in the studio: How do I keep freshness *and* finish? How much does the viewer need to know? How much do I want to say?

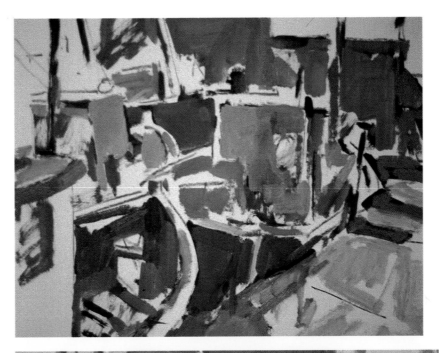

Step 4

"Finishing" the picture is a matter of adding a bit of detail. The design of the picture is fairly obvious: It's a giant wheel. The lines on the wharf, the ropes, and the gunnels and tops of cabins point towards the center of the picture. That's where the eye rests—the "focal point"—but only briefly. The pattern of the picture should keep your eyes moving all around it. The edges of the picture are kept simple. But not too simple. Strong colors going *out* of the painting give the viewer a sense of something beyond the frame. That adds breadth. Have you noticed how part of a picture sometimes seems livelier than the whole? When painting it, the painter's energy wasn't constrained by a sense of the frame. So here's another problem: A good design works off the frame, but too rigid a concern for the limits of the frame can deaden the picture.

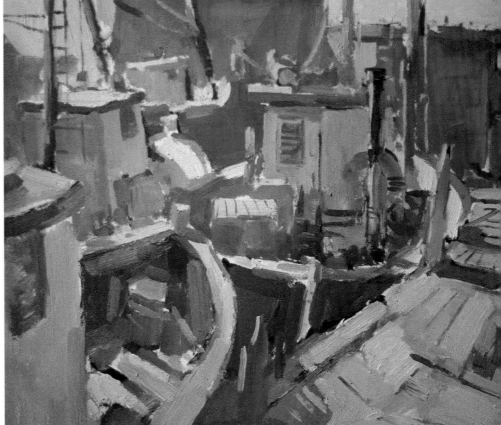

Chapter Four
Shape

The basic mark of painting is a shape. Shape is visual but is also apprehended by touch and muscular action. You are not ready to become a designer until you renounce the painting of *things* and embrace shape painting. Painter Eugene Speicher defined the painter as "a distinguished shapemaker." Objects before our eyes are not bounded by lines. They appear to be shapes of color value which fit one against another. An object can be perceived only as it corresponds to an organized shape.

Let us define shapes as they emerge on our paper as marks. A shape is bounded by line, points, values, colors and textures. A shape depends on the relative position of points comprising its outline. Very large shapes on our picture are called areas. A shape need not necessarily resemble an object. A simple shape is not necessarily limited to a single object, but may be a composite shape. Background shapes around a figure or within a figure are negative shapes. Since they usually indicate space they are also negative spaces. Sometimes shapes represent shade, shadow and light. Normally these are shapes within a shape.

It is the shape of a friend that we recognize from a distance, long before we see the friend's color or features. We apprehend much from a silhouette. Texture is implied by the characteristics of the shape's edge.

What Makes a Good Shape?

Directional. A good shape is longer in one direction. Poor shapes have equal dimensions. Circles, squares and equilateral triangles are poor shapes. Because they are self-contained, they defy integration. The smallest shape is a dot. Despite its smallness, it becomes assertive when isolated. A circular shape, though the simplest, is the worst for pictorial use. It lacks stimulation. Since circles in perspective are elliptical, they are less offensive. Almost as bad as circles are squares and equilateral triangles. These three shapes, having no direction, lack visual character despite their geometrical purity. To avoid static shapes, stretch them out so each one goes somewhere. Of course, it is absurd to stretch a shape so far that it becomes worm-like.

Oblique. A good shape is, or contains, an oblique. This means the edge of the shape, or more impor-

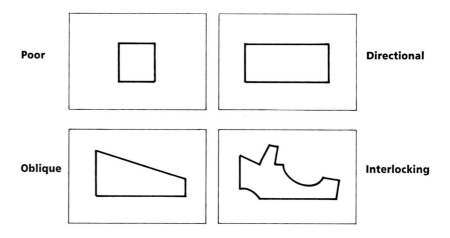

Poor

Directional

Oblique

Interlocking

tant its axis, is slanting in relation to the picture's border line. Shapes lurking parallel to the border are not exciting.

Interlocking. A good shape interlocks with adjacent shapes in the manner of a jigsaw puzzle. Interlocking holds the picture's parts together. Shapes should also interlock with the background. A poor shape is a shape that would roll if cut out and thrown on the floor.

Here is a summary definition of a good shape: It has two different

dimensions, is oblique, and is interlocking.

Variety of Edge. Edges around a shape need variety. There are only three kinds of edge: hard, soft, and rough. The best shapes use all three.

Choose the Best Silhouette. Many objects best reveal their identity in a certain viewpoint; for example, a side view of a duck or a human head, or a top view of a hand.

Soaring in the Rockies
© 1985 by Paul E. Rendel
Acrylic
28″ × 40″

(Above.) Two rocky prominences are linked by a shadow shape. Dark rocks are interlocked with frosted light values.

Española Valley, New Mexico
© 1987 by Nat Youngblood
Oil
27″ × 48″

(Left.) See how Nat echoes his ground shapes in his sky. Long horizontal shapes are carefully overlapped or interrupted.

Concave vs. Convex

All shapes of the human body and most shapes of living things are convex. Convexity suggests the outward thrust of growth and vitality while concavity expresses extreme passivity. Thus painter John Carlson suggested using convexity in mountains, trees and all natural forms. Concavity is reserved for ocean waves, snow drifts and hanging lines.

Weaving Shapes. Shapes in a painting may be over- and/or underlapped to weave them together. A web not only fosters a spatial sensation, but is an extremely powerful integrator. Ingres, the great draftsman, concurs, "The drawing is like a basket. You cannot remove a cane without making a hole."

Gradation. Gradate shapes from fat to thin, or vice versa. Typically, tree limbs get thinner as they become more distant from the trunk. Shape gradation can be initiated in negative shapes if positives are tilted.

Avoid Parallel Edges. Foliage and cloud shapes should not parallel other elements in a picture. Nor should any topmost point or incident be positioned immediately above or below a bottommost point or incident. Avoid placing one shape or incident immediately across from another. The position of all shapes and incidents should shift and alternate.

Mnemonic Shapes. Perceived shapes are compared with stored data (concepts). Under poor visual conditions, a shape can be easily differentiated from its environment if the artist is familiar with the standard toward which the shape aspires. Portrait painters rely on mnemonic shapes of light and shade. They compare these to the present model and the present light.

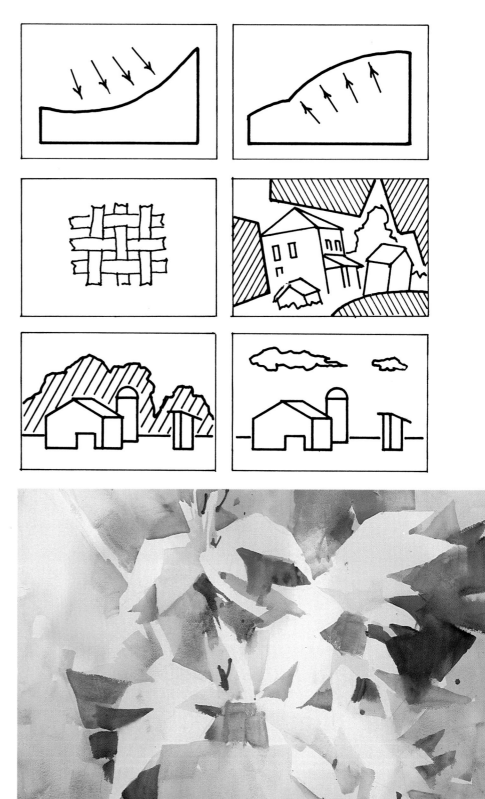

Floral Congratulations!
by Frank Webb
Watercolor
15" × 22"

I tilt, push back, tear off, overlap and consolidate to avoid a boring bouquet look.

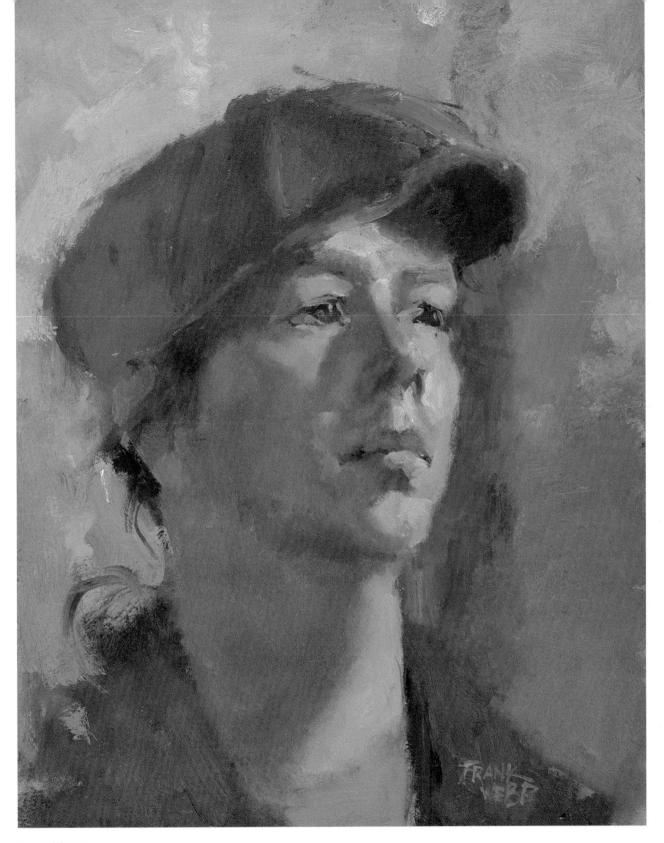

Boy With Cap
by Frank Webb
Oil
14″ × 11″

The mnemonic shade pattern here is typical. The human head always tends to make memorable light and shade shapes.

Shape Passage

Edges of shapes should disappear here and there, melting into other shapes. Passages not only tie shapes together but provide lost and found interest. Passage also simplifies by combining shapes.

Shape Overlap

From the very first, draw shapes to overlap others. This is the strongest spatial sensation available. It makes shapes more interesting since the concealed portions of shape require our imaginations to fill them in. Especially overlap the boring shapes of circles and squares.

Positive and Negative

These terms refer to things, and to the space around things, respectively. Negative areas should be designed with more loving care than the positives, for they are often neglected while the positives take care of themselves. Settle for nothing less than *great* negative shapes.

Valentine to the Artist's Wife
by Frank Marcello
Oil
24″ × 48″

A valentine heart shape is paramount in this portrait. A figure hugging itself is a sign of oneness and integration.

Automatic Shape

Many painters make free doodles. A spontaneous drawing appeals to our muscles, bones and viscera. The abstract expressionists were often called action painters because of the beauty they captured with their automatic markmaking. Try an automatic drawing to vitalize your painting. Shapes grow one from another and tie together in a wonderful way. Before you start a drawing, make some free gestures over the paper without touching it. Gestures pull areas together, encourage breadth of effect and thwart hemstitching.

Determining Shape

Some shapes are generated with outline, other shapes are scribbled from the inside out. There is a proud tradition behind each. The outline painter is apt to get a better pattern, with the work tending toward the inorganic. The other, who works from the inside out, works in the way that nature works. Organic things grow from the inside outward.

Shape Contrast

Though we need to provide repeating shapes for the sake of integration, we must also initiate contrast of shape for the sake of interest. Any scheme must have opposition in it. Thus, in a picture of oval flower shapes, a few opposing rectangular pots or a tabletop is a relief.

Simplify Shape

Some subjects lack character. Vitalize them by re-creating them with reference to the cone, the cube, the sphere and the cylinder. Seventeen discernable segments forming an irresolute shape might be reduced to three or four; thus

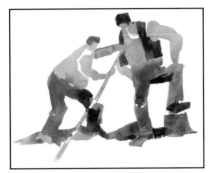

(Above.) These wash shapes were made directly with a flat brush. There was no preliminary drawing or model.

each change in direction will become significant. "Brevity gives point to speech," according to D.W. Prall, the author of *Aesthetic Judgment*. "Simplification is the liberating of what is significant from what is not," said Clive Bell.

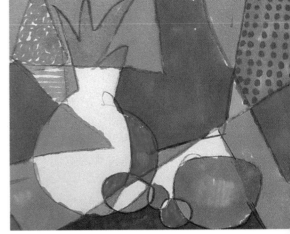

(Above.) This preliminary automatic drawing, made with color markers, began with free sweeps.

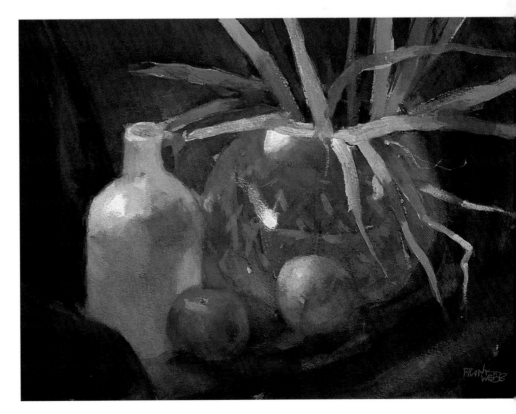

Red Still Life
by Frank Webb
Gouache
15″×22″

Shape contrast is desirable but one kind of shape must dominate the scheme.

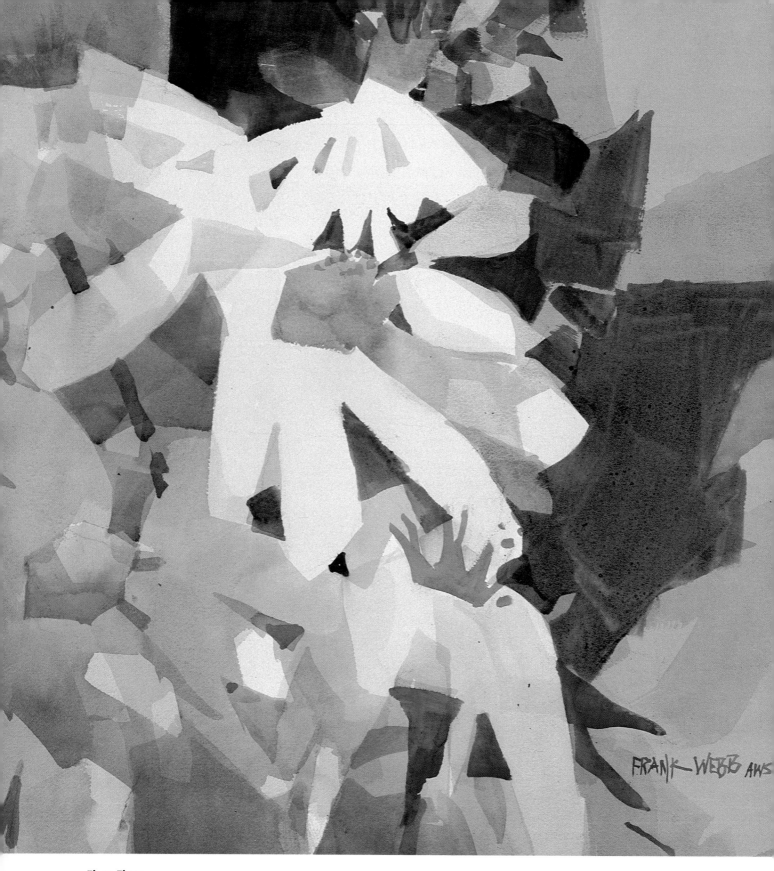

Flora Flora
by Frank Webb
Watercolor
22″ × 17″

Painted in flat layers with a drying time
between, this procedure generates trans-
parent, integrated shapes.

Layered Shapes

Throw a deck of cards on the table. You will have a definite sense of overlap, resulting from the random fragments of other cards or bits of table showing around the top layers. In a painting, shapes may be applied to suggest overlapping to give a spatial effect, or to change a value, color or direction.

Shaped by Shape

After making a shape we must respond to that shape, perhaps modifying it or its neighbors. Each consecutive mark or shape must relate to earlier shapes and to those that will follow. Thus, as we make shapes, shapes make us. It is a reciprocal active/passive experience. As Will James wrote, "Your experience is constantly transformed by your deeds." A shape should spawn similarities, that is, an important shape, having visual identity, should repeat itself in the scheme. This responding to shape-making results in a dialogue between the artist and the work.

Oaxaca Church
by Frank Webb
Watercolor
15" × 22"

Another example of shaped layers, this one began with a mother-color of yellow with a little sepia. Plain yellow is not dark enough to be a middle value.

Port Clyde Afternoon
© 1990 by Judith Blain
Watercolor
18″ × 24″

(Above.) Judy's road penetrates the space and still remains a good flat shape despite its depth.

Trees Along the Mountainside
by Lu Priore
Mixed media
15″ × 22″
Collection of Blue Cross of Western Pennsylvania

(Right.) Texture and color plus good negative painting express the subject. This vignette (there are not many good ones) is an undeniably fine shape.

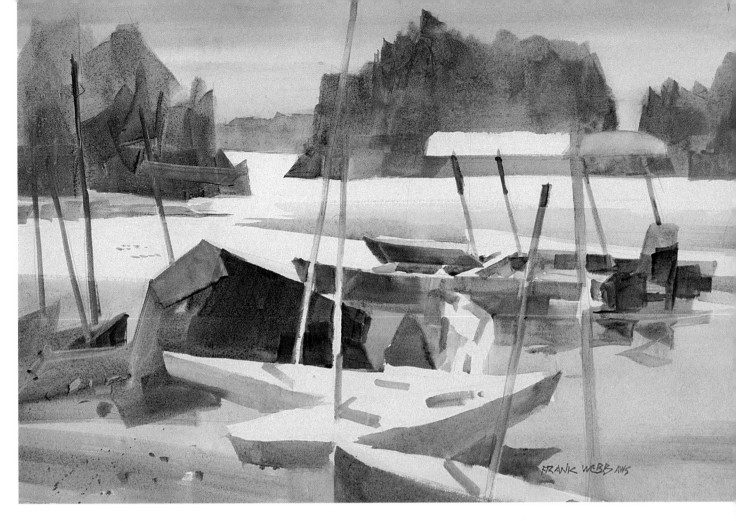

Lake Naomi Boat Club
by Frank Webb
Watercolor
15" × 22"

(Above.) There were no such rocks present. The picture needed to be tied up just like the boats. Otherwise both would drift aimlessly.

Shapes are thick and shapes are
 thin,
And I'm not proud of the one I'm in;
But the ones I brush
Are rich and lush
Because they're stretched and
 interlockin'.
 — Frank Webb

Tips

• Shapes within a shape may be seen as values, colors or textures. Make sure these are good shapes.

• Brushstrokes should interlock and vary in size and direction. There is a beauty in an unmolested paint mark.

• Make one shape larger than all the others.

• Feel the gesture of a shape. You are not only a spectator but a participant. Even a rock should have gesture. Try to feel the forces a rock "feels."

• Draw the big shapes first. Then divide them into smaller ones. Think large, then small.

• Try some optional shapes on tracing paper placed over your drawing.

• Constantly look for opportunities to merge, consolidate and gather shapes together.

• As you draw, think of contour as a line between value shapes and not as an outline of an object.

• Avoid tangents. Do not allow shapes to have a common border. It confuses space.

• Avoid isolated shapes that do not consort with others. Use overlaps and configuration. Don't snob, hobnob.

• Cross-fertilize shapes. Pretend the tree is a human figure or the cloud a bear. Such speculation may improve a shape.

Chapter Five

Value

Value is the quantity of light in paint marks. Approximately nine value steps can be made with paint. Though it is impossible to match the thousand steps of daylight, nine steps can suggest the effects of natural light and shade. Comparative values are the basis of painting, for without values we would have no shapes, textures, intervals or sizes. Painter Edwin Dickinson explained, "Plane relationships are more representational through comparative value than through implications of contour drawing."

There are two different value systems. The first system is nature's values. These are the values we see all around us. The painter needs to know and see these values objectively and must have technical skill to paint these values as seen. This presents a dilemma, however, because these values have no pictorial strategy.

The other system is compositional values. The two systems may correspond to some degree but they also differ, because while nature is not in the picture-making business, art is man-made order. Compositional values are those values needed by the picture to produce contrast and unity. In art, unity is the sole criteria. Compositional values substitute what *should be* for what is. They are re-created to convey the painter's concept and emotion. Those painters who have learned to sort out the two systems and use qualities from each are able to create more exciting pictures. This chapter explores both systems.

Seeing Values

Seeing came before words. We are immersed in seeing. When we first open the eyes, the immediate awareness is one of color. The seduction of color prevents us from knowing or caring about the underlying structures of value, line, shape, size and direction. The allure of color is so captivating that it seems a hopeless task to get some beginning students to see values apart from hues.

The best way to learn values is by making life drawings, still lifes, or landscapes with a scale of achromatic values. A very lifelike effect is possible with the values of black, white and gray. One cannot make music without the scales, but unlike music, our scale has only one octave. All of our tones are in eight or nine steps. All good paintings have been made from this handful of values. Painters don't need more values but a more discriminating use of the available few. We create light by withholding light. "The artist labors after light with the tools of darkness," said John F.A. Taylor.

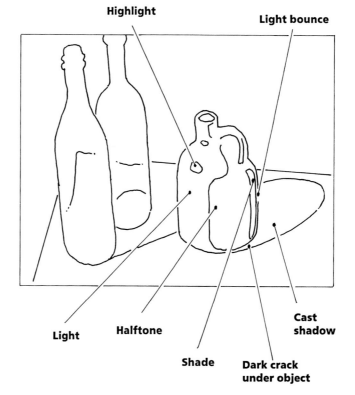

Bottled Light
by Frank Webb
Oil
12″ × 16″

A still life painted from observation. The light source was indirect, hence shadows are soft-edged.

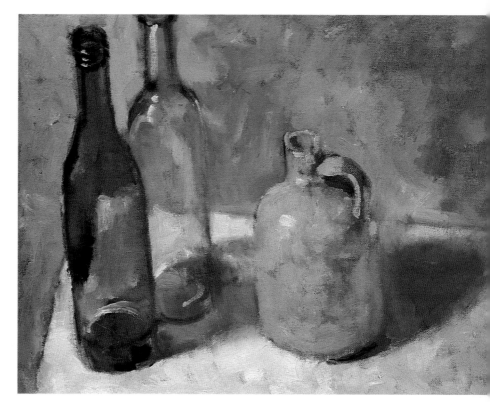

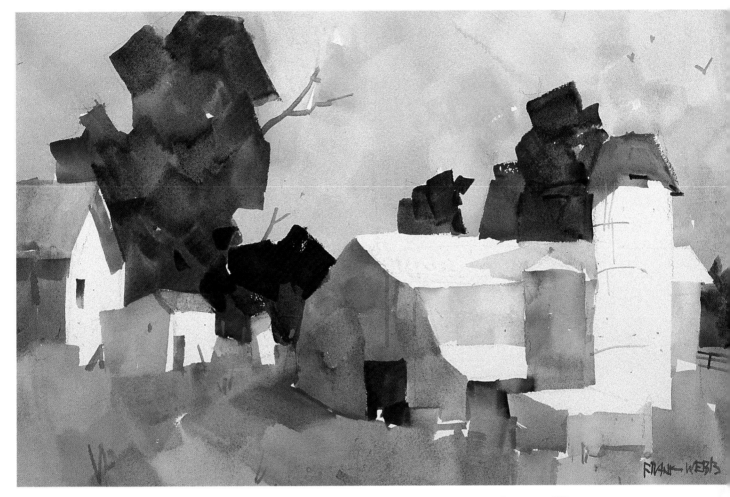

Natural light indicates seven values: highlight, light, halftone, shade, bounce, cast shadow, and the crevice under the object. These values are seen on any object posed beneath a single light source. Outdoors the sky is the main light, with the land somewhat darker. A slanting plane such as a mountain is darker yet, and upright planes such as trees are darkest. White buildings or other objects with strong local value will be exceptions.

Farm on the Battenkill
by Frank Webb
Watercolor
15″ × 22″

A sketch made in three values. I painted with broken color trying to hold each value against other large values.

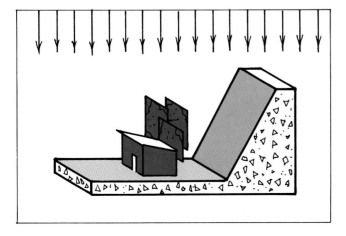

Studio Three
by Frank Webb
Oil
11" × 14"

Diffraction can be seen on the muntins of the window and is also seen on the sash left and right.

Detail of
***Little Moose River* (on page 87)**
This is an example of diffraction as it applies to sky holes seen through foliage.

Diffraction

The early twentieth-century American impressionist Birge Harrison coined the word "refraction." Later John Carlson used "diffraction" to describe the effect of one mass of tonal value upon its adjoining mass. Diffraction is a property of the eye. A large mass of foliage against a light-valued sky will cause the sky value to darken as it approaches the foliage and will cause the dark mass to lighten as it nears the light.

Diffraction is concerned with edges—but it doesn't mean softened edges. It must be used with finesse so that it is not noticed by the art viewer. Diffraction enables the painter to avoid an "edgy" look without softening edges. It gives an atmospheric feeling.

This principle is especially noticed in nature when viewing small isolated values. If a small dark value, such as a flagpole, is seen against a light sky, its value is bleached. And if a small light value, such as a piece of sky, is seen within dark foliage of a tree, it becomes darker. (See the detail at left for an example.) Therefore, any small value becomes compromised when it is engulfed within a large contrasting value, and it should be painted with a diffraction adjustment. It is rare to see diffraction in a painting today. It is especially rare in watercolor. It requires a deliberate finesse to paint it. Perhaps it is time to reclaim it. Check Whistler's work to see it exemplified.

Value Fudging

Compare the sky with the earth. If you attempt to match the real contrast in your painting, the sky will become too light and will attract too much attention. Generally, an adjustment must be made between the heavens and the earth so that greater value contrasts can be used at the center of interest. Look at some museum paintings and see how great artists create a fictitious but convincing relationship.

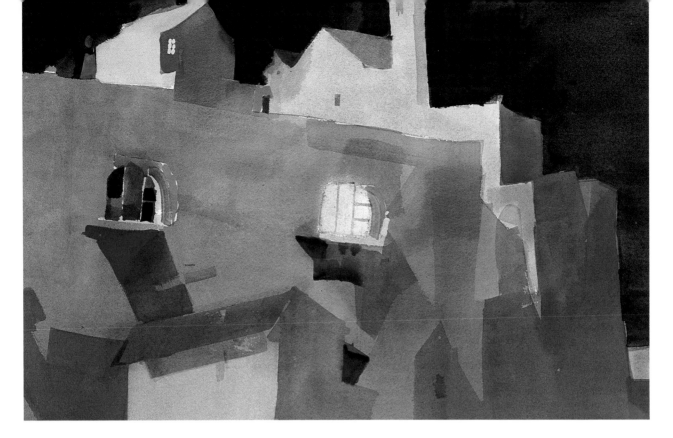

Key Values

If most values in a picture are above mid-value, the picture is in a high key. If most values are below middle, it is in a low key. The *key* of a painting is a means of expression. A forest interior iş low key and a beach is high key.

Taxco Nights
by Frank Webb
Watercolor
15″ × 22″

(Above.) Roosters were crowing, Mexicans were singing, the cathedral bell was sounding. This low-key painting expresses my delight.

Boston Mills Slope
by Frank Webb
Watercolor
15″ × 22″

(Below.) Of course, a snow scene is best expressed as high key. In this relationship darks become very attractive.

Congregate Values

For breadth of effect pull together your large lights and play them against the gathered-together darks. Avoid putting darks in the light and don't put lights into the shade areas. Nor should the bounce (light reflection) in the shade be too light. Halftones belonging to the light area give the impression of color and texture and should be made lighter than they appear in your subject. Also, halftones appearing as part of the shade pattern usually describe form and should be darker than they appear. The aim, again, is to get breadth by giving a convincing stretch of light with our limited values.

Surface Modulations

Since we must paint within a limited scale of about nine values, we must simplify and make each value count. When viewing a subject or a model, avoid showing all the small changes of value and concentrate on the large values. The beginner usually exaggerates highlights, resulting in a flashy, cheap look, as though everything were made of chrome or satin. Use restraint in highlighting and avoid over-modeling. For the same reason, avoid overstating halftones. They must be kept simple and light enough to stay in the light area, separate from the shade.

Edges

There are three kinds of edges: hard, soft, and rough. A hard edge commands attention but is the most trite, and it discourages eye movement. However, if one were forced to make a painting with only one kind of edge, the hard edge would be the most useful.

A soft edge invites the eye to pass from one shape to another. It adds mystery and mirrors reality,

for when we look at any view, we can see only a few square inches with hard, clear focus.

Most of what we see is out of focus. If you don't believe this, try to count the number of leaves on a branch of a tree while focused on one leaf. We assume we see large areas in focus because our eye constantly moves and scans. For a convincing spatial sensation, you should soften a contour when it crosses behind another contour. A contour of a fuzzy object will also be best expressed as a soft edge. For composition's sake, the painter may also soften many contours in nonstrategic areas of the painting, thereby giving greater attraction to the center of interest with the use of contrasting hard edges.

A rough edge may express a texture such as the contour of foliage. A rough edge may also be used for variety (composition). It usually indicates a roughness of the entire shape.

Christy
by Frank Webb
Oil on toned panel
14″ × 11″
Collection of Barbara McGovern

(A) Lost edges add atmosphere, variety and relief. (B) Hair and costume are connected with value passage. (C) Reflected light adds color intensity and illumination to otherwise bland shade. (D) Study the variety you will see at the edge of eye sockets.

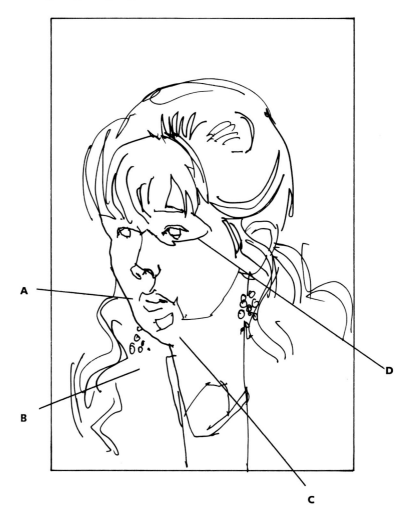

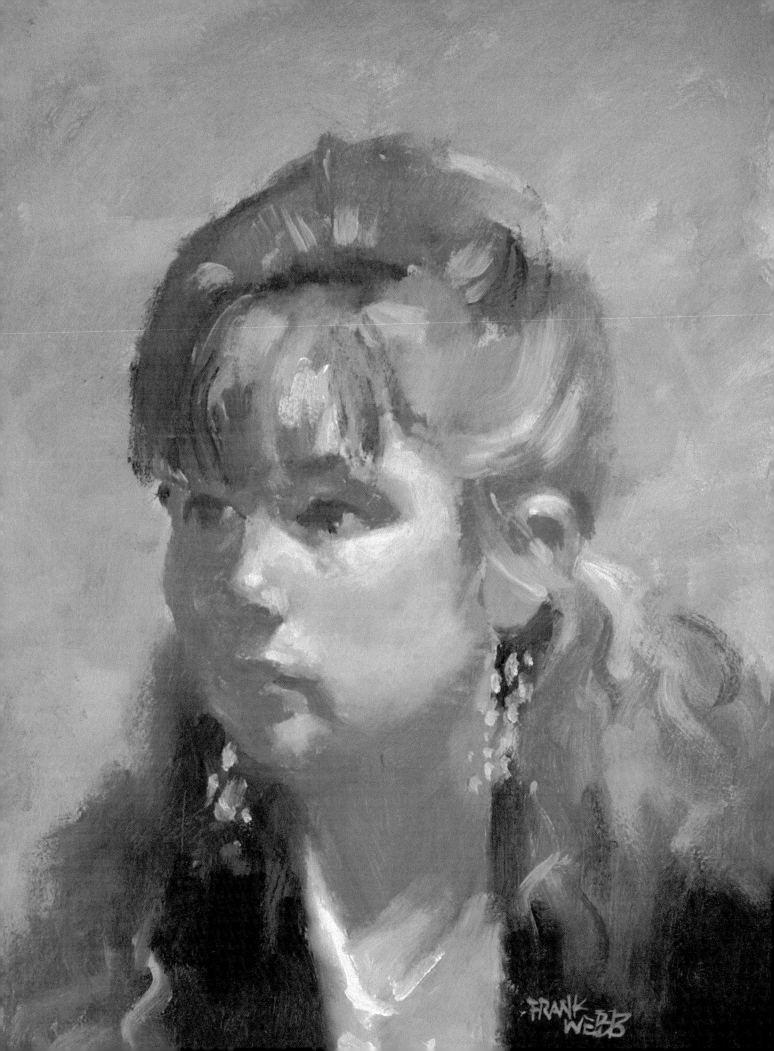

Aerial Perspective

Distant values flatten and lighten. Think of blue translucent veils hanging between you and distant shapes. Distant shapes should be reduced to silhouettes, encouraging the eye to dwell on the center of interest rather than wandering into the distance.

Value Limitations

The truth of light and the truth of dark cannot be realized at the same time except when the subject is seen in dim light. The Old Masters, especially Rembrandt, concentrated attention on the light end of the value scale. Because they aimed to show all nuances of value in the light they were into black by the time they reached the halftones. Hence, because they sought the truth of all comparative values of the light areas, their paintings became loaded with dark areas. Turner and other moderns split from this approach. They went after the truth of the shade and darks. By the time they got up to the halftones they were into light. Hence their works are higher (lighter) in key. This also paved the way for using luminous color in shadows, which heretofore had been dark brown.

Thus far, values have been considered in a limited and passive context, as practiced by those who try to paint what they see. The following will describe a more dynamic and creative use of values. It is not intended to lure the painter from naturalism, but to suggest a leap into composed realism. The importance is not so much one of style but whether a work, however realistic, is creative, has unity, and expresses what life feels like.

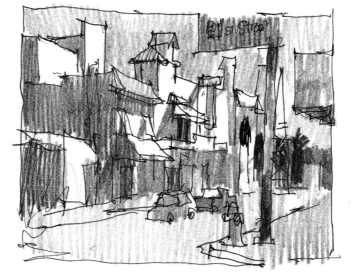

My first on-location sketch of Vero Beach has too much tunnel effect of perspective and values are scattered.

Using a blunt marker I redesign by stressing flat planes which parallel the picture's surface.

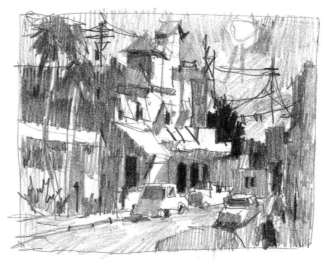

I place a piece of typing paper over the second sketch and trace its shapes. Now I focus on value allocation.

Compositional Values

The composer has a much more complex problem than one who is content to copy eyesight values. The problem is to paint expressively and to adjust parts so that they properly take their place relative to the whole.

Sizes. Sizes of value pieces must be adjusted. Don't copy sizes of values as seen, but adjust sizes to conform to our visual *idea*. For contrast's sake, make three sizes: large, mid-sized, and small. And for the sake of unity make one largest size of value. This will normally be a middle value. A creative allocation of values was taught by anatomist George Bridgman: "No two tones of equal size or intensity should appear above one another or side by side; their arrangement should be shifting and alternating. There should be a decided difference between the tones. The number of tones should be as few as possible."

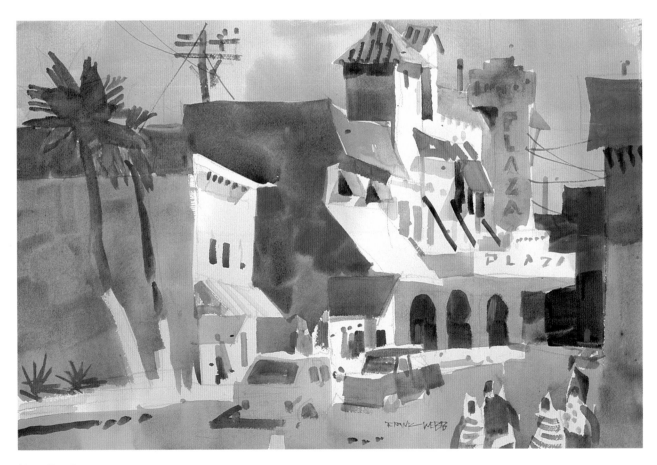

Vero Beach
by Frank Webb
Watercolor
15″ × 22″

I began with a cool, wet-into-wet underpainting using light values. After the underpaint was dry, I painted directly with warm colors exclusively.

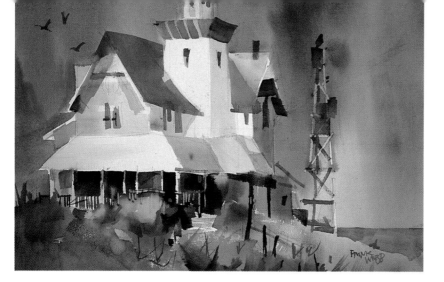

Sea Girt Light
by Frank Webb
Watercolor
15" × 22"

(Above.) Gradations in the sky express natural light and the glory of watercolor.

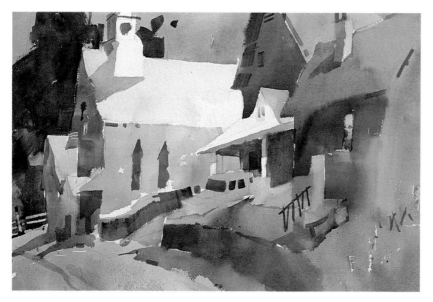

Jacksonville, Vermont
by Frank Webb
Watercolor
15" × 22"

(Above.) Typically, trees are darker than shade on houses because of their local value and velvetlike texture, and because vertical planes receive less illumination.

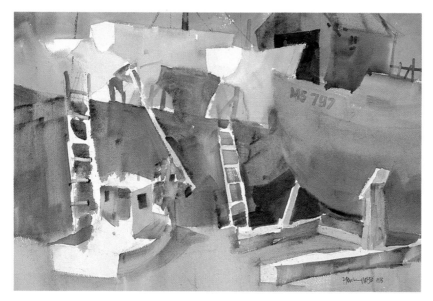

Gradation

Large areas especially benefit from gradation. Value gradations are most energetic when they run in opposing directions.

Local Value

Values come from three sources: (1) light and shade resulting from illumination, (2) needs of design in each particular picture, and (3) local value. Local value is a quality of the object. Typically, a light coat will be seen as light whether observed in bright sunlight or moonlight. In a complex subject local value can help differentiate between objects. The same is true of various local colors.

Passage or Linkage

When a value comes near another similar value, a lost edge will make a bridge between the values. Passages of this kind produce eye circulation. Passages should also be made between positive images and background. The idea of passage can be clarified if we consider its opposite—the bull's-eye. The familiar bull's-eye is any value completely surrounded by another value. Avoid this because the eye gets trapped in an area and dies, with eye circulation cut off.

Rockport Boatyard
by Frank Webb
Watercolor
15" × 22"

(Left.) Not only are large darks linked and played against large lights but also cools are gathered and played against large warms.

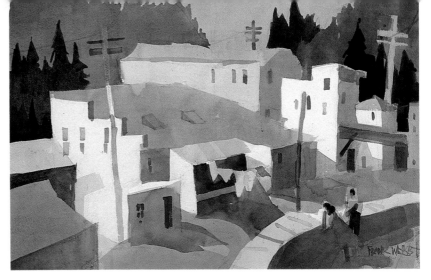

Directions

There are three possible directions for your value marks to take in relation to a given shape. When painting a value into a shape, painting along the shape results in hardness. Painting across the shape, softness. Crisscrossing strokes suggest atmosphere.

Shade/Shadow

These two are often painted separately. Try uniting them, making one value shape. It is forthright, simple, and integrating.

Alternating Contrasts

Also called counterchange or reciprocal values, a deliberate reversal of value contrasts adds sparkle and puts space into a picture. It forces one to engage negative space as well as positive.

Thomas, West Virginia
by Frank Webb
Watercolor
15" × 20"

(Above.) See how the backs of the buildings combine shade with shadows cast across the alley.

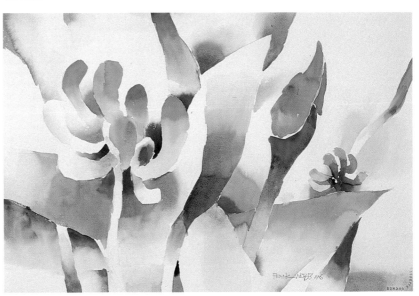

Floral Space
by Frank Webb
Watercolor
15" × 22"

(Above.) Follow any tone here and see how it alternates darker or lighter in relation to its background.

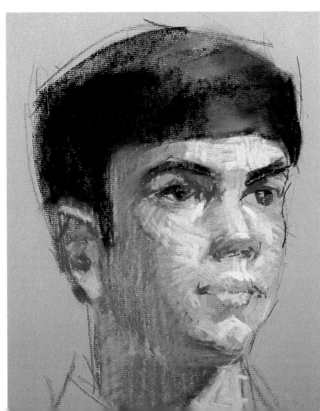

Rick
by Frank Webb
Pastel on toned paper
Life-size

(Left.) Most of these strokes follow the form. Pastel teaches how to make each stroke count.

Plan 1.
White Field

A: Large dark gray, middle-sized light gray and small black. **B:** Large black, middle-sized dark gray and small light gray. **C:** Large light gray, middle-sized black and small dark gray.

1A

1B

1C

Plan 2.
Light Gray Field

A: Large dark gray, middle-sized white and small black. **B:** Large black, middle-sized dark gray and small white. **C:** Large white, middle-sized black and small dark gray.

2A

2B

2C

Plan 3.
Dark Gray Field

A: Large light gray, middle-sized white and small black. **B:** Large black, middle-sized light gray and small white. **C:** Large white, middle-sized black and small light gray.

3A

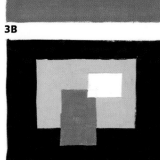

3B

3C

Plan 4.
Black Field

A: Large white, middle-sized light gray and small dark gray. **B:** Large light gray, middle-sized dark gray and small white. **C:** Large dark gray, middle-sized white and small light gray.

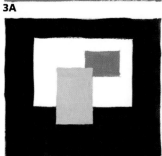

4A

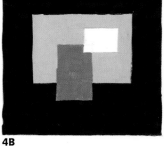

4B

4C

Plan 5.
Checkerboard or Busy All Over

5

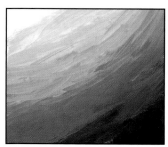

6

Plan 6.
Gradation of Value in Any Direction

The oblique direction is the most exciting.

Six Value Plans

On the facing page are the six possible plots for value, each offering the maximum contrast available with art media. These plans are the basis of graphic art whatever the style or medium.

Though nine value steps are available, it is best to plan with only four. Any value plan careens out of control unless limited. A picture reads most clearly when it is built on four, well-separated values.

With a soft pencil you can easily indicate four values.

Sometimes it is more dramatic to flatten all the values as though the subject were front-lit. Without the usual light and shade, subtle value and color nuances gain significance. Manet worked this way, with clear color, unsullied by over-modeling and complex halftones.

Sketches are normally incomplete and that very incompleteness is their charm. Most sketches are basically line drawings even

though some shading is indicated. Sketches of this type make the transcription into a painting very difficult. A special kind of sketch is called for—one that shows the masses of all values. Though it begins with a groping line, it seeks to shape value pieces rather than show contours of objects. Here is the procedure: Make a graphic border line in the same proportion as the painting. Lightly outline whites. Next, scribble a middle value around whites. Middle value

This is plan 1A.
These plans were made with a black marker and Ebony pencil.

Plan 2A.
I made all strokes vertically to minimize effects of modeling or direction.

Plan 3A.
This plan is the closest to the natural values of the outdoor subject.

Plan 4B.
This plan suggests night. It pays to scribble several of these to discover the most expressive plan.

is the body that holds the painting together; against it one can see both lights and darks. Mid-value should be carried all the way out to the border lines, sparing only planned white shapes. Whites become visible as pieces of value only when value surrounds them. Next, darker mid-values are applied, followed by darks.

Without a complete statement of comparative values the painter is destined to (1) poor composition, (2) composing during the painting process, or (3) reliance on luck. With an exciting value sketch one can devote full attention to color and technique during the painting process. Color is more likely to be clear and decisive when the mark is placed on the surface *once* with the right value, the right hue, the right intensity, the right size, and the right shape.

Experiment with several value plans. Try shifting shapes, sizes, and directions. Look at some format options. Scribble some various keys. Try a high horizon or a low one. A far shot or a close-up. All these should be freely made value shapes.

As one student was making a bad painting, the instructor asked if there were any sketches or design ideas for this work in progress. "No," said the student, "I like to work creatively." Possibly the student meant "spontaneously." There is a widespread notion that improvisation is apt to be more creative. Perhaps it is for some artists, but even the most spontaneous work must have good composition. Some media lend themselves to major adjusting. Other media are less forgiving. An initial compositional sketch helps teach the painter what is needed for the picture. Unorganized values are chaotic just as unorganized sound is noise. The painter's chosen tones are to natures' values as music is to sound.

(Above.) Placement of the largest shape is made within border lines. Curves and straights are combined. I redo this stage until I get a great gesture and fine angles.

(Above.) A blunt Ebony pencil loosely scribbles in a mid-value. I use vertical strokes to avoid making a modeled drawing.

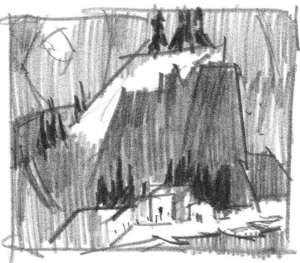

(Right.) Darks are placed to dramatize whites. If I need greater detail it will be made during the process of painting.

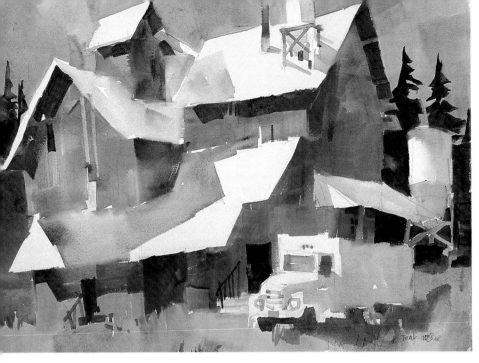

Hudson Elevator West
by Frank Webb
Watercolor
22″ × 30″

(Left.) Cast shadows on the white roofs were invented because we should not merely paint what we see but what ought to be.

Pocono Bridge
by Frank Webb
Watercolor
15″ × 22″

(Right.) This is a large white and a small dark in mid-values. The autumn color was made up. A picture is an invention.

Harry's Sugar House
by Frank Webb
Watercolor
15″ × 22″

(Left.) Normally, I paint around whites in watercolor. On this occasion I scrubbed out the white vapor shape.

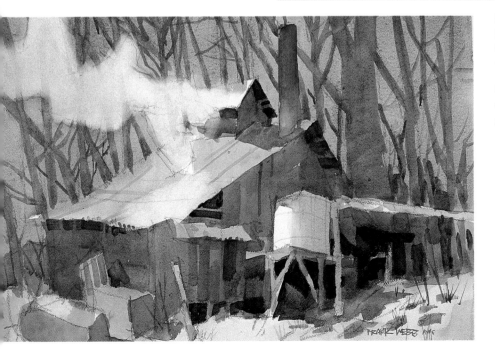

Covered Bridge
by Frank Webb
Watercolor
22" × 30"

The job of the darks is to introduce us to
the all-important whites.

Tips

• Place a middle value first for a better grasp of the whole gamut of value and to reveal lights. Then add darks.

• Try middle-value gray paper for preliminaries, applying white and dark chalk or pencil tones.

• Look at a subject or a color painting through a blue or a red glass. This screens out most of the color and shows values. A black-and-white photo and a camcorder viewfinder also show values without hue.

• A small halo of light accents an edge where it meets a dark. Or, conversely, a small gradation of darker value will relax the same edge.

• A photo of a sunlit subject usually blackens cast shadows. Lighten these and put more color into them.

• Alternate value contrasts along extended edges. This puts air into the picture and weaves the subject into pictorial space.

• The darkest value of shade is found just before it turns into light.

• Don't put darkest or lightest values at the edge of the painting. They more properly belong at the center of interest.

• If you wish to get simplicity into your landscape try going out to see your subject by moonlight. There it will declare itself in simple masses. (If only we could hold on to that idea during daylight.)

• Don't go so anxiously for highlights and the accents without using that great body of mid-value.

• When making a compositional drawing see the sky and the trees as pieces of value. Later they may become sky and trees.

• It takes a value change to separate a tree from the sky. Don't rely on a color change to separate it. Even worse, don't rely on texture. Rely on value.

• Be sure to separate your big values with differentiated steps. "The unreadable will shortly be un-read." —Jacques Barzum.

• Local values of the subject may be used, limited, or eliminated as needed by your design.

• Most brighter colors come to full intensity in mid-value.

• Don't become snarled in too many small values and overmodeling. They are fussy and thwart breadth.

• Experiment with collage for value patterns. With gray, white and black paper you can avoid the distracting influence of linear effects.

• When value gradations are used to render light on a curved surface, get more spunk into the surface by making a series of harder-edged value steps (French blend). It is especially useful when working in gouache.

• Don't squander precious limited values at the outside edges of shapes in order to make the form go around. It saps the lifeblood out of your big value hunks. If your big values are right you don't need to make the form go around.

• Omit unnecessary values.

• Look at the subject and/or the painting with a black mirror. It is made of a simple piece of glass or Plexiglas with a black backing. This crude mirror reflects a low-key version of the image with emphasized variations of light values. All values below halftone run together in blackness—instant Rembrandt!

• Give most of your attention to the four to seven largest pieces of value in your painting. If these few large hunks are not the most distinguished shapes you can make, your picture will fail.

Light, shade, halftone and tint,

They were part of Leonardo's stint.

Shunning values galore,

He simplified more,

And His Holiness paid him a mint!

—Frank Webb

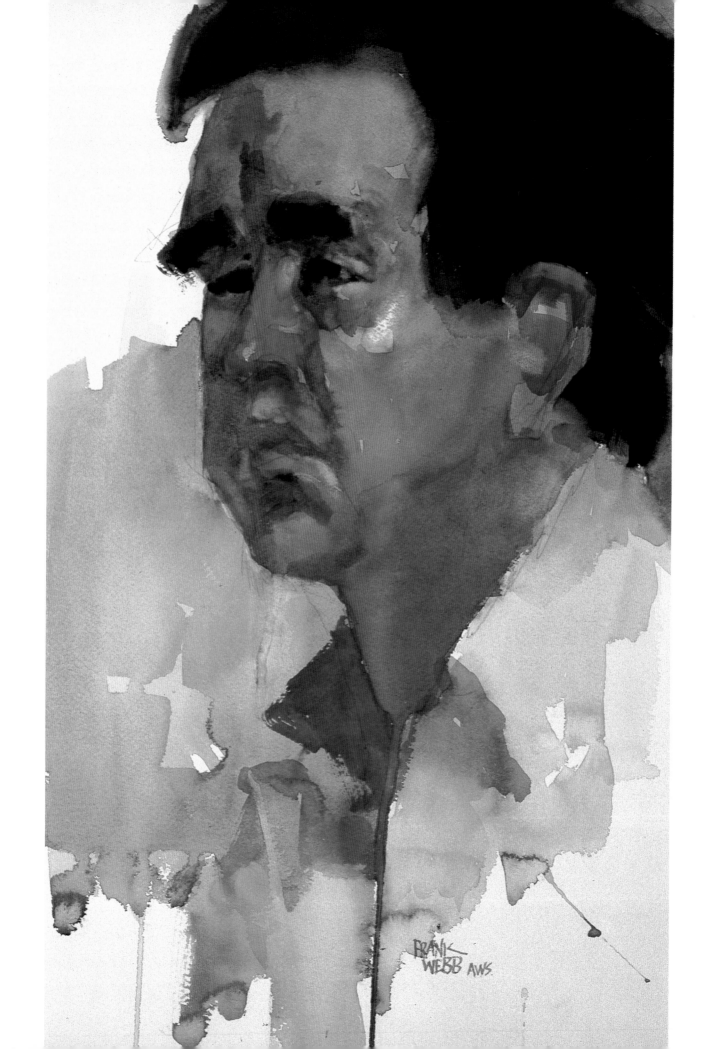

Chapter Six
Color

What more appropriate spokesman for artistic color than Delacroix, who said, "The two conceptions of painting, that of color as color and of light as light, have got to be reconciled in a single operation." Experience tells me that my feeling for color has been aided by compositional ideas. My marks of color must relate to each other. The following theory, therefore, intends to tie together your feeling for color with basic design ideas. With fusion of color and composition, the color marks you make will be sure.

Light exists outside of the self, but color is subjective — taking place within the eye and the brain. While line, shape and size need to be created by concept, color is omnipresent, even to the barbarian's eye.

Color must be felt and not merely seen. Color's magnificence makes a joy of the painter's work. It blesses the most humble subject. Of all the elements of art it is the most intimate, emotional and the most immediate. The color composer is free from the physicist's theories of color and from the tyranny of the subject. Color should not be a passive imitation but should come from feeling, the palette and our compositional idea.

Color Terms

Painters commonly use four color terms.

Hue. The everyday names of colors such as red, yellow, blue. There is no universally accepted language of color as there is for music. Not only are we unable to agree on some names of hues but differences of value and intensity go unnamed. The most popular color wheel shows twelve bright hues in a spectrum.

Value. The lightness or darkness of a hue—the value as it would appear in a black-and-white photo. Values are steps between gradients of light and dark. Each hue of the spectrum has its own home value. If a hue is made lighter than its home value, it is a tint. A hue darker than home value is a shade.

Intensity. Intensity is to color as loudness is to sound. It is brightness of hue as contrasted with grayness. Other terms that mean intensity are *chroma* and *saturation.* A certain pitch of sound can be loud or soft without changing pitch and a color may be more or less intense without a change of hue. Intensity is influenced, unwittingly, by value changes. For example, when a paint is lightened with white, it generally loses intensity due to its dilution, and it is also diminished when black or another dark is added. Intensity is more commonly lowered by adding gray or a complement.

Temperature. The warm half of the spectrum is adjacent to orange and is opposed by the cool half, adjacent to blue. Interaction of warm and cool excites color, both in the contrast of large shapes and in small touches. Any single color is not absolutely warm or cool, but only in relation to another color or a group. The warm half of the color wheel is thought to be three times as luminous as the cool half.

Other Color Terms

Primary colors are red, yellow and blue.

Secondary colors are orange, green and violet.

Intermediate colors are yellow-green, blue-green, blue-violet, yellow-orange, red-orange and red-violet.

Tertiary color is a mixture of two secondaries. Thus, a tertiary color contains some of each of the primary colors. Green and violet make olive, green and orange make citrine, and orange and violet make russet. These three tertiaries are very low-intensity relatives of the bright primaries—red, yellow and blue.

Tone is neutralized color.

Pigment is coloring matter, usually a powder. (The word is often used incorrectly to mean "paint.")

Paint is a pigment mixed with a vehicle. It is also sometimes a lake. A *lake* is a dye precipitated into an inert base to give it body as a paint.

Simultaneous contrast results from one color's influence on an adjacent color. In such a comparison, there may be an apparent change of hue, value or intensity.

Luminosity is the light from within—such as the white of a watercolor paper under the paint, or the white ground of a primer under oil paint.

Tinting strength refers to a paint's ability to influence another color in a mixture, tinting or shading.

Iridescence is a color effect seen in oil films, soap bubbles, etc. It is caused by refraction or reflection.

Top-tone is the apparent color of paint heaped up on the palette.

Undertone is the brighter hue revealed when some dark paints are mixed with white, typically, burnt sienna and phthalo blue.

Color Wheel

The twelve-color wheel is the most widely used since it displays the twelve brightest colors with maximum differentiation. With yellow, the lightest value, at top, warms are at the left and cools at the right. On each side, succeeding colors become darker as they near the bottom of the wheel, showing the differences in each color's home value.

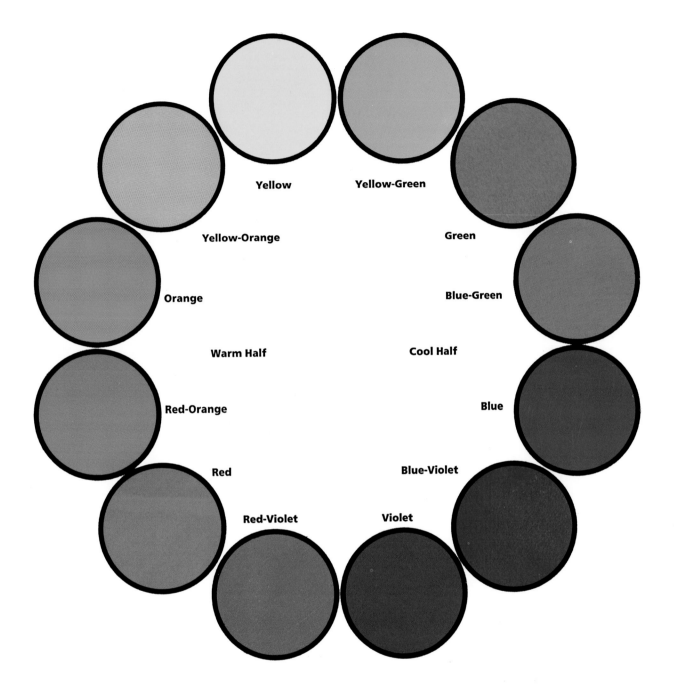

Yellow

Yellow-Green

Yellow-Orange

Green

Orange

Blue-Green

Warm Half

Cool Half

Red-Orange

Blue

Red

Blue-Violet

Red-Violet

Violet

Color Relationships

Though the painter relies most heavily on how color functions emotionally, the following will describe the most common relationship schemes. The diagrams below suggest how to organize color. Each illustration selects one arrangement, but one might apply each principle to other colors on the wheel.

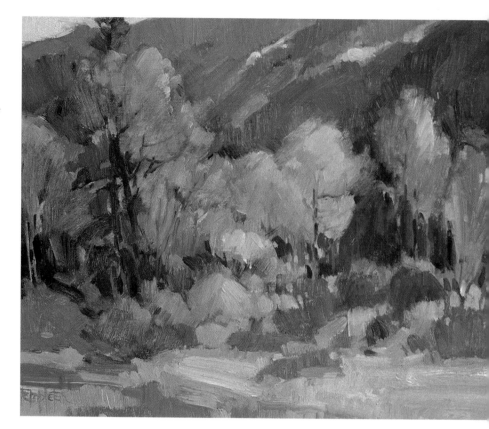

Cottonwood Valley
© 1992 by Ann Templeton
Oil
14″ × 18″

This is an exciting complementary scheme. Yellow-orange dominates the blue-violet.

Complementary Color

A color's complement is the same as its afterimage. This is found by looking at a color for half a minute and then looking at a white background. A color's complement is its opposite on the color wheel. Complementary paints mix to produce gray. For this reason, beware of their static potential in mixtures. If, however, they are not mixed but placed side by side, they intensify one another.

Near-Complements

Because complements produce gray, a near-complement offers a wider range of color effects.

Split Complements

This arrangement may result in the same neutrality as a complementary scheme since the two near-complements together equal the complement.

Poppies
© 1992 by Betty Phillips
Watercolor
20″ × 28″

An unequal triad of red-orange, red-violet
and yellow-green.

Analogous Color

This is made from three or four adjacent hues on the color wheel. Though harmonious, analogous colors have little contrast. Contrast, however, can be made by value or intensity.

Equal Triads

In each possible combination, two of the colors may mix to produce a complement of the third. Because they're at equal intervals on the color wheel, triads may lack vitality.

Unequal Triads

These triads give the widest variety yet have harmony due to unequal intervals.

Gateway Fleet
by Frank Webb
Watercolor
15″ × 22″

(Right.) Almost monochromatically yellow-orange, there are nuances of red-orange and neutralized bits of gray-green and gray-blue.

The Skier
by Lu Priore
Watercolor
15″ × 22″
Collection of Frank Webb

(Below.) Simplicity is the key to color here. Intense red-orange is contrasted with neutralized blue-green.

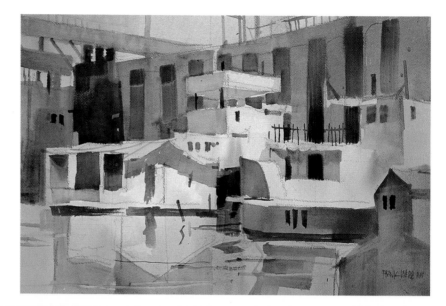

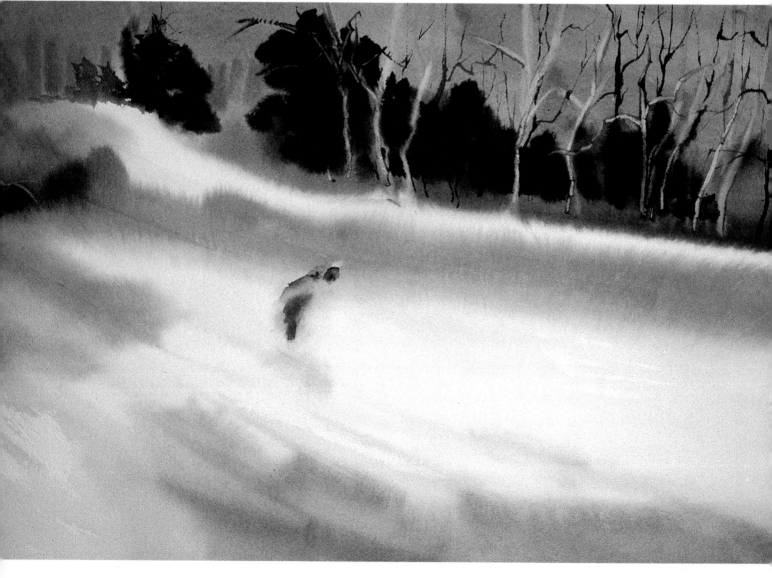

Triad Including Gray

When two warm hues and a gray are used, simultaneous contrast causes gray to take on the appearance of a complement. One of the two hues should be made dominant. Historically, this is a tested favorite device of portrait painters, who used red, yellow and gray. Gray and yellow suggest green, gray and red suggest violet and, most obligingly, gray indicates cool tones without the usual mud resulting from blue or green.

This demonstration portrait uses only the following oil colors: cadmium red light, cadmium yellow, black and white. Adding yellow to gray suggests green, and adding gray to red suggests violet.

Toned Color

In this demonstration the oil palette of eight colors was set in advance of painting. Cobalt blue was added to each color in the ratio of one to three parts. As you can see, the cool colors kept their identity while the red and yellows were compromised. Any color may be used as toner; remember that its complements will be most noticeably changed. The painting was made with the addition of white to the flesh areas, whereas the color swatches are shown without the addition of white. Toned colors automatically have harmony. This procedure may be followed in any liquid paint media.

The toning color, cobalt blue, is shown at top left. Next is lemon yellow and burnt sienna. In the second row is cadmium red light. In the third row are black, viridian, alizarin crimson and ochre. These were scraped with a knife so you could see the hues a little better.

Limited Palettes

Much can be learned by excluding color. For instance, in palettes limited to earth colors, each color seems richer than when in the company of bright ones. Restraint is often impressive — it gives the beholder the notion that you have big guns in reserve. And one feels free when working within one's own chosen limitations. Real mastery is almost always contingent on being able to do much with little. I have favorite triads and two-color palettes. The simplest palette is made of two colors — burnt sienna and Prussian blue, for instance. This palette enables you to express warm vs. cool, gray vs. bright, and of course, dark vs. light. You may elect to place a bright accent from outside your limited palette, but often it is best to remain within your limits.

Strictly speaking, the limit is not so much on your palette as in your color concept. A limited palette almost guarantees color harmony. So often one sees that a painter has gone whole hog, leaving nothing out and thereby putting nothing noteworthy in. The fun of experimenting is that you make your own limits. They are not imposed by others. It is good for most of us to make do with less — we become better managers.

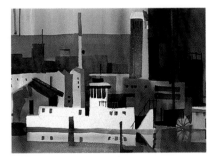

Yellow ochre, ultramarine and cadmium red light.

Acra red, ochre and black.

Acra red, ochre and Payne's gray.

Burnt sienna and Payne's gray.

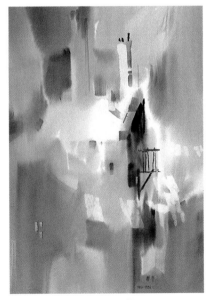

Alizarin crimson and viridian.

Prussian blue and burnt sienna.

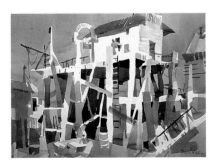

Lemon yellow, Payne's gray and alizarin crimson.

Color Scintillation

The painter works with opposing colors to imbue the picture with feeling. It was said of Delacroix that he "had a sun in his head and a storm in his heart; for forty years he played on the keyboard of human emotion."

The practice of applying color in painting is fundamentally the manner in which we place the warm against the cool. Outside, the warm sunlight itself suggests this; its warmth is dramatized by the amount of blue and purple that gets bounced into shade by the blue sky. But if the painter mixes warm and cool together on the palette the result is likely to become mud. Therefore we use certain techniques to preserve the liveliness of colors and to keep them from cancelling one another.

Vibration of color is an effect in the eye of the beholder. If the painter places small complementary colors in close proximity, they slightly irritate the retina, giving off an energy akin to daylight. This was the magnificent discovery of the French Impressionists. Perhaps it became shopworn before they died for most of them gave up extreme divisionism. Impressionism not only produced an overly-insistent, spotted surface, but it tended to negate drawing and design. There are ways to apply the principle of divisionism without resorting to painting in little spots. On these two pages are some of my favorite ways to play the warm against the cool using various media. The aim is to partially combine by the use of a visual mixture, that is, the colors are mixed in the eye of the beholder.

Watercolor. Wet cool is deftly laid into wet warm with minimum agitation. See *Bird of Paradise* on page 20.

Watercolor. Patches of various warms and cools in common values are placed in juxtaposition with blended edges. See *Studio Three* on page 60.

Pastel. A warm color is stroked onto a cool-toned paper. Both are the same tonal value.

Watercolor. Wet cools are superimposed over various dry warm colors. See *Jardine* on page 118.

Watercolor. A settled (or granulated) wash of cool is applied over a dry warm wash.

Pastel. Cool strokes are drawn into a warm undertone. For sparkle, avoid rubbing. See *Rick* on page 67.

Oil. Red is allowed to dry on a rough canvas. Blue is applied with a knife, which deposits color in valleys.

Oil. A cool blue is glazed over a dry warm ground. A glazing medium gives body and transparency.

Oil. A cool scumble is applied to the lower half. A scumble is a thin application of an opaque paint.

Oil. Pointillism—obviously the most assertive visual mixture and the least natural.

Oil. A cool blue is lightly brushed into a wet, warm underpainting. It works best on canvas.

Oil. A brush loaded with cool blue is put on a dry, opaque-toned ground.

Pastel. Cools and warms are put down as contrasting touches on white paper.

Oil. Hot color is applied to a dry, cool gray imprimatura (a canvas stained with transparent color).

Pencil. Cross-hatchings of color lines are built up in alternating directions and temperatures.

Demonstration ▪ Frank Webb

Painting Cool Into Warm

The scene was fantastic. I couldn't wait to make a fistful of drawings and I only had an hour. I saw immediately that the star actors were the straight tree trunks growing up behind the big rock. This was the main contradiction of value and direction. I avoided making duplicate angles and made unequal intervals between tree trunks.

Six months later in the studio I can still smell the pine trees and hear the gurgles. I decide to work in oil by first underpainting in warm colors. I use no thinner, but scrub the paint into the canvas using worn-down, stiff brushes. The first layer is made entirely with warm color. As usual, I try to keep white paint out of my darks. My colors are alizarin crimson, ochre, Mars violet and umber. I try to cover all the white of the canvas in priming.

Now I cover all this warm color with cooler color, mingling cool with the warm without too much agitation. I add to my palette the cool colors of ultramarine, viridian and rose madder, and a couple of bright warm colors, cadmium red light and lemon yellow. I match the values of the still wet underpainting. My tonal values match but because the hues are opposed I get a vibration.

I make the left side of the sky blue but add green to the right side. The canvas aids and abets this kind of operation because the interstices of the fabric hold more paint than a smooth surface. Some warm touches are applied. I find that I have to load a wide flat brush and really zap the sky with a lighter value. To give this tint the requisite amount of strong blue, I resort to Prussian blue, loading the brush to the hilt. I can't help myself; I love brushwork.

Sketch
This was one of several graphite pencil sketches made on the spot.

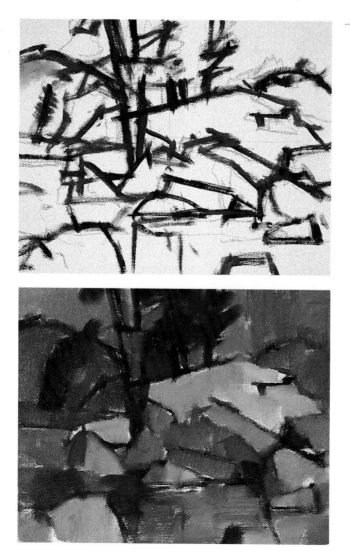

Step 1
Warm underpaint is applied. Stiff brushes are used to scrub on undiluted paint.

Step 2
Cool color is laid into the wet, warm paint. I avoid mixing them as much as possible.

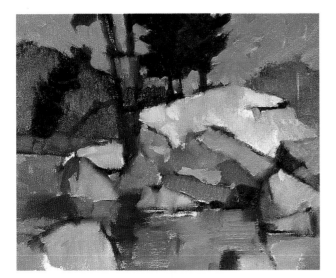

Step 3
Additional adjustments of cool into warm
are made over the entire canvas.

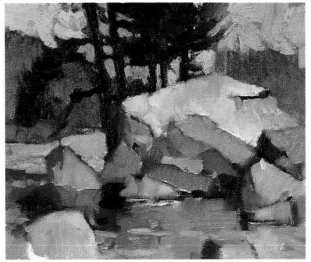

Step 4
The sky value lacks contrast with other ele-
ments. I mix a lighter tone of Prussian blue
and lay it on in thick slabs.

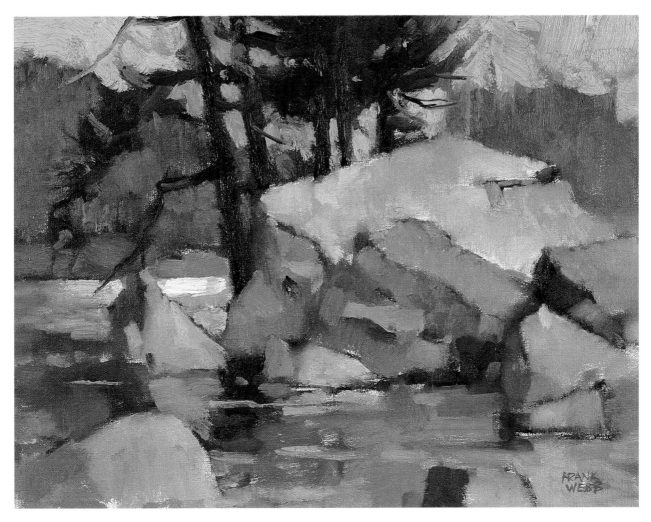

Little Moose River
by Frank Webb
Oil on canvas
11″ × 14″

Minor adjustments, details and accents
complete the painting.

Noon Shoppers
by Frank Webb
Watercolor
15" × 22"

This was painted directly on dry paper. I painted the sky quite cold with Prussian blue. Against this I played warm with the rest of the paper.

Color Dominance

Color dominance is always achieved by the color occupying the greatest area. Intensity does not contribute to dominance.

The early Italian tonalists rendered form in light and shade almost exclusively in values. Today, artists render form not only in values, but with hues and intensities. One need not go whole hog for all the spectrum. A little color can suggest the spectrum, even when limited to one cool and one warm color. Too great a contrast of light and shade are the enemies of color. Too much light and shade also

compromises composition by destroying flatness.

For Brighter Color. Take a clue from Constable and the Impressionists and get light and color into your shade. Raise the key and brighten the color. They also show us how to substitute contextual color for local color, enabling us to savor a picture's color in one visual grasp.

Harmony or Contrast

Any pair of complements will either cancel or intensify each other in accordance with sizes or comparison. Small, juxtaposed complementary touches mix in the eye, producing optical gray. Another strange color effect may be seen when a strong color such as yellow is introduced into a scheme: it tends to show up all other subtle yellows in adjacent mixtures. This seems to be in opposition to the theory that a color reinforces its complement, but size, intensity and value are also involved. So a color may be brought out by contrast as well as by harmony.

Diane
by Frank Marcello
Oil on canvas
50″ × 40″

Color harmony is realized by yellow and a repeat, played against blue and a repeat. Both repeats have variations. (A frame within a frame.)

Color Gradations

A gradation is a slight changing of conditions across an area of color so that one end is warmer or cooler, darker or lighter, brighter or more dull. Gradation in large areas generates a feeling of progression, therefore life.

If two colors meet with too much vehemence, you may neutralize each as it nears the border. This operation harmonizes the colors. On the other hand, if the composition requires *more* contrast, we may increase the intensity of each color so they will clash at the edge. Here, as in other discussions, we don't take these ideas as rules, but as if-so propositions.

Painting the Picture

Few painters consult a color wheel while painting. Nor do they select a handful of swatches as a buyer of drapes might do. Knowledge of plans, wheels, chips and diagrams is helpful in the same sense that it is useful to study a language. However, we don't use this knowledge mechanically, just as during speaking or writing one does not consciously think about grammar rules. Paintbrush in hand, the painter stands before the blank paper and before a subject, real or imagined. During the heat of creation the painter must fuse together concept, composition, technique and color. The best word to describe the painter's problem is *context*. This context has never been seen before. So, there stands the painter, armed with deductions and intuitions born out of experience. Now the painter must act, and in that acting must be responsive to the needs of the unique vision unveiling before his eyes. Color must be found anew in each painting.

A warm and cool color are placed one beside the other with a hard edge.

At the edge each color is gradated with its opposite. The edge becomes inconspicuous though it still remains a hard edge.

Here the edge is emphasized by increasing the intensity of each color. They clash at the border.

Burnt sienna, yellow ochre and
 black,
Velasquez was on the right track;
They worked well in Spain
But I've tried them in vain;
The teacher must hold something
 back.
 —Dick Barrett

Tips

• Warm colors make the most pleasing shades (darks) while cool ones make the best tints.

• A line or a value may be absolutely wrong but color is always relative.

• Color makes objects clearer and helps place the focus. As with values, keep colors separated.

• Colored objects bounce their respective colors into each other.

• Don't repeat a background color on the object. It would mean there is a hole in the subject and we see background coming through. The two areas would seem to be on the same plane.

• Color effects will not substitute for poor or boring composition.

• The painting made with nothing but tints is chalky and vapid.

• Don't put right color over wrong color. Better to first scrape or wash the wrong color away.

• The drama is dissipated if you put too many intermediate steps between the big color marks.

• Since you probably have intervals of hue and value, now add intervals of intensity.

• "Attack things in a broad, simple way; and when done, you will find certain faults of color which you can correct . . . in another picture," said William Morris Hunt.

• Try putting a mother-color down over all or most of the support. Then paint frank color into it.

• For spunky color, plan the picture with a dominance of mid-value. That's where color lives.

• The concept of dominance does not mean monochrome painting. Use as many colors as you like but they must be enveloped by the dominant.

• Flesh color of any race is more lifelike if it contains nuances of cools to give it quality.

• For a lively note, straddle the color. If it is yellow, paint it with modulations of yellow-orange and yellow-green.

• Decide whether to use strokes along the form or strokes which ignore the form. The latter technique is seen in the works of the Impressionists and Cézanne.

• Whatever the medium, try to avoid an overmixing of colors both on the palette and on the surface.

• When modeling form, remember that a change in hue, value or intensity is a sign that the form changes direction.

• Don't make a blue sky of gross blue and white paint. First, whatever the medium, lay down a pink or an ochre layer the same value as the intended blue. Then paint the blue into it for a luminous effect.

• Black placed near colors makes them appear lighter and brighter.

• Shift hue a little whenever a value changes.

• Optical mixture adds mystery. Optical mixture takes place in the beholder's eye as it views the broken colors of pointillism, or layers of contrasting, transparent color.

• Naum Gabo lectured that black and white are positive colors. Though science says nay, his idea is true for painting.

• Don't worry too much if you don't have full-spectrum light or north light in your studio. Your work will hang in someone's normal room lighting. Of course, good lighting is desirable if possible. Under incandescent light, yellows and oranges are intensified while blues and purples are weakened. Outdoors in daylight, these effects are reversed.

• Omit unnecessary color.

• Color does not come from the factory but from you.

• A painting must be true to itself. If you draw and use light in the representational mode, let your color also be natural. Maintain a consistency of realism or abstractionism throughout.

• Don't paint what is there—paint what ought to be there.

• Use resting places of black, white, and gray among your colors.

• It is usually better to lighten or darken a color with another color instead of white or black. If you have added white already, avoid adding black. Sometimes it is shockingly correct to use black to paint a black area.

• Hold the value and change the color, and other times hold the color and change the value.

• Any large area will likely improve with a gradation of hue, value or intensity.

• You may elect, as I do, to design in values and then go spontaneously into color on the painting. This is exciting. If I first solve other design problems, I know with each stroke why I am touching that area.

• Acres of clear color are muddied by touching areas too often. Each time a brushload touches an area already wet with paint, purity and brilliance are compromised. Once a color is set down on a surface, it is difficult to add to its intensity except when a thick layer is superimposed.

• Adjust what you see by what you know. What you know is via all the senses and remembering.

• Charles Hawthorne summed up the whole painting activity as "putting one spot of color next to another."

Chapter Seven
Texture

Awareness and orientation to the world come primarily through the eye. It is a little-known fact that some of our visual sense has been developed through the sense of touch. Thus, texture is experienced even when using the eyes only. Texture, associated with touch (tactile sense), is closely allied with emotional feeling. We say that we will keep in *touch*, or, "I *feel* that this is the right policy," or, "I had a *rough* time," or, "This was *smooth* sailing."

Let's trace the history of representational art, beginning with the Old Masters who associated sight with touch. They painted more from knowledge and less by eye. In the seventeenth century Velasquez was the first to break from this tradition, painting with an emphasis on visual appearance. His work was pivotal. Whereas most paintings had been made of parts, which were seen separately, Velasquez is deemed to be the first to have seen the model in one total visual grasp and to paint that all-at-once vision. In the nineteenth century, the Impressionists carried visual impression further as they added prismatic color to the play of light. Local color was replaced with contextual color. In the 1960s representational art began to be influenced by photorealism. This "ism" required a high fidelity of texture and a return to local value and local color.

Photo Finish

Today the photograph has beaten everyone at the texture game. No Renaissance master could dish up such faithful and delicate texture as the camera. With one blink of the shutter, a photograph flaunts softness, roughness, wetness and dryness, in either glossy or matt. Tactile qualities are so unified into an image that the two senses of sight and touch are almost fused.

It is futile to compete with the camera by trying to equal its richness and exactness of absolute texture. Better stick to creating better shapes, values, color, sizes and directions than your camera can make. Trust your own heart, eyes and brain.

Expressive Textural Marks

As we face the model or the subject there is no more reason to copy texture than there is to copy the subject's incidental shapes and sizes. If we paint in the representational mode we should select, reject and imagine texture as needed. Bypass imitation and focus on the essence of a subject. For hardness of rock, use straight line and hard edge. For softness of foliage, use soft edges and curves. Water should look wet, a cloud should float, and the sky should be clear and fresh. Emphasize essence.

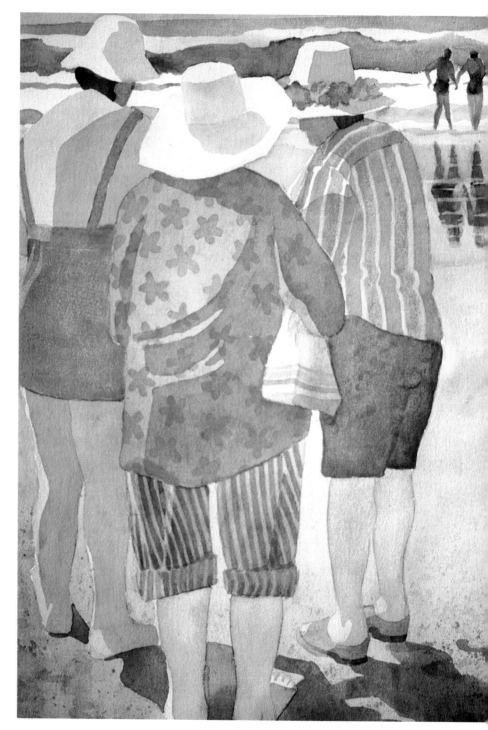

The Beach Stroll
by Tee Herrington
Watercolor
30″ × 22″
Collection of Mark Maisel

(Above.) Good simple shapes and well placed pieces of value are augmented by pattern on costumes.

Devon Wyatt
© 1985 by Robert Schmalzried
Acrylic
24″ × 36″
Collection of Richard B. Wyatt

(Right.) Values, color and textures combine to give off the energy of a checkerboard (fifth value plan).

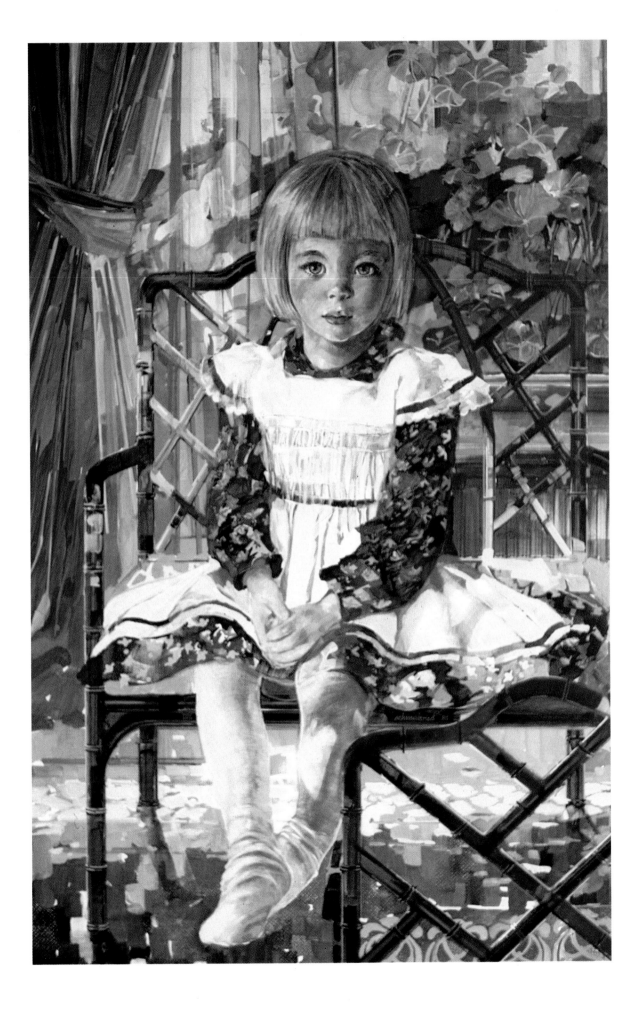

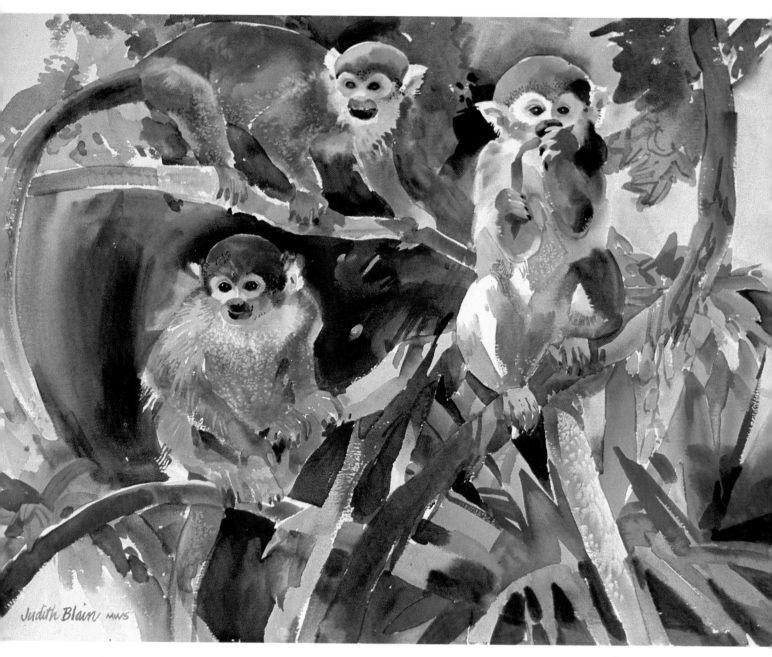

Spider Monkey Trio
© 1992 by Judith Blain
Watercolor
15″×22″

Foliage, hair, wood, nails—all help to make a richer communication. Watercolor's luminosity contributes to this presentation.

Media Texture

Media itself has textural scope. Most media may be put down soft or hard, rough or smooth, glossy or matt, thick or thin, dry or wet. A painter's enjoyment includes the subtle feel of media manipulations: squeezing paint from tubes, the fluidity of watercolor, the bite of charcoal, the slither of graphite, the scratch of the pen, and the drag of stand oil.

Texture of Content

In art, natural textures may be imitated. In photorealism and in trompe l'oeil paintings, the painter is especially scrupulous about textural rendition. The aim is to almost fool the eye into seeing the subject minus brushstroke and paint.

Texture of Composition

Marks of both smooth and rough textures give contrast. Unity is achieved by making one of them dominant. Integrate textures by repeating them. Gradation of texture is from rough to smooth, dense to sparse, or coarse to fine. Texture of paper or canvas influences value and color marks because they look different on various surfaces.

Of the seven paint marks, texture is the most expendable. The wise composer uses it as the icing on the cake of value and color; but first make the cake.

Beach Scrap
by Robert Cronauer
Watercolor
22″ × 30″
Collection of the artist

Convolutions galore make a textured surface and unify the painting. Note the effective use of the see-through to the ocean.

Lace

Your eye will always be attracted to lace. Lace is the intervals between twigs, fence fabric, hanging lines, rigging, etc. Lace may be positive or negative, or better yet, both. The magnetic qualities of lace should be used creatively in a painting, especially at the center of interest where it helps to draw the eye. Don't overlook the big lace which lies between tree trunks or under a pier. Irregular lace is much more interesting because of the variations in sizes and shapes of intervals. If you make at least seven intervals in a piece of lace, it reveals itself as an unbounded shape. It also takes on a certain amount of dazzle, which is why it attracts the eye.

Lace also has a spatial effect. It can be used to show bits of nicely shaped negative pieces of distant space. Perhaps we feel secure looking through a grille, just as the family cat enjoys looking out from under a chair.

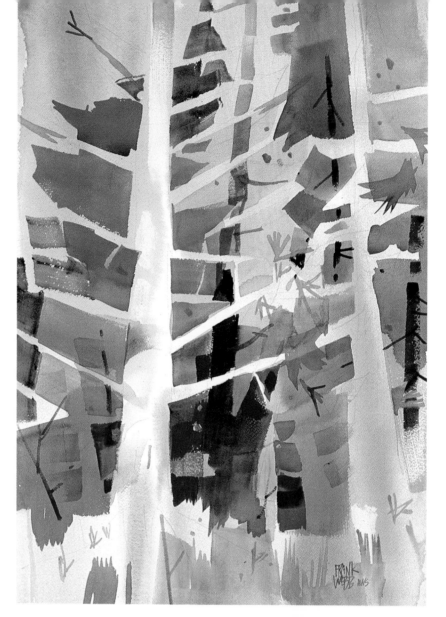

Monhegan Forest
by Frank Webb
Watercolor
22″ × 15″

(Right, top.) Negative spaces are conceived as lace. Most of the shapes are painted as negative shapes.

New Orleans Ferry
by Frank Webb
Watercolor
22″ × 30″

(Right.) Again, as above, lace activates space, but this lace is mostly positive.

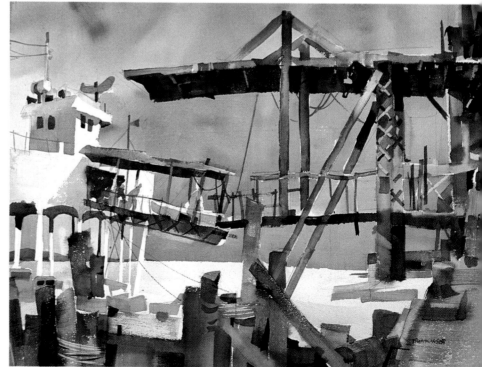

Flat vs. Deep

Flat texture is the overall texture of an area such as floor tile or wallpaper. You have seen paintings by Henri Matisse where he will add stripes or a textured pattern to clinch the presence of a wall or floor. You too can use texture to animate your painting and to delight the eye with decorative effects, especially when contrasted with noneventful areas.

To differentiate from the flat, there is deep texture. This is texture seen in the halftones that occur between light and shade on illuminated objects. Texture is revealed there because the slanting light rays reveal so much. Artists traditionally expect to find a wealth of not only texture at the halftone but also color. Even if the remaining tones are flat, we will usually impute the texture of a whole object from its outer contour (silhouette) and the halftone.

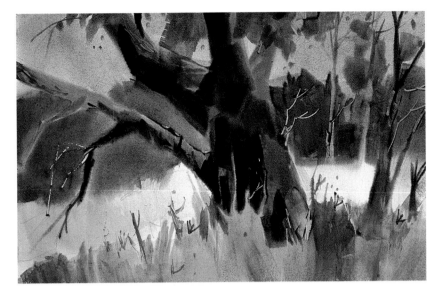

Arbor Daylight
by Frank Webb
Watercolor
15″ × 22″

(Right, top.) Grasses in this foreground express positive textures against the light meadow, and negative textures against the dark tree.

Model and Blanket
by Frank Webb
Watercolor
30″ × 22″

(Right.) In a vignette such as this, an uneventful background is dramatized by a decorative pattern on the blanket.

The Red Rider
by Frank Webb
Oil
14″ × 11″

To exploit unctuous brushwork I add oil
and resin to give a certain stickiness to the
paint. Let paint be paint.

Tips

● If your values and colors are deliberately flat and postery try a coarse canvas or rough paper. Texture adds interest to a sleepy surface.

● Don't expect texture to replace or substitute for a poor value plan. You must build bone and muscle (value) before putting on the skin.

● As painted images recede into the distance, textures should be eliminated.

● Texture can differentiate parts of a painting, though value and color are more effective.

● A formal use of texture can activate dead areas, balance weights, entertain, and clinch the *thereness* of surface.

● Since we "see" with the sense of touch as much as with the eye, use softness, roughness, wetness and dryness to give validity to certain areas.

● Experiment with unorthodox manners of applying paint. Stamp, stipple, squeegee, blot, squirt, drip, spritz, spread or extrude.

● Transparent media offer stimulating textural qualities since superimposed transparencies declare the sensuous surface.

● Too much textural contrast in a painting produces disunity. Beware of extreme smoothness in one area and high impasto in other areas.

● Extreme brightness will tend to make texture invisible. Therefore, if you wish a light value to take on a luminous look, eliminate texture.

● The textures of nature are a given and every surface has one. You, the painter, need to sense these, but more important you need to seek out and allocate texture with positive intention and not merely copy nature's texture.

Weird Woodland
by Frank Webb
Watercolor
15″ × 22″

I seldom resort to salt and textural gimmicks, but now is the time. The forest is the ultimate texture.

Rough and smooth, though unalike

Whet my texture appetite.

In fact I'm really

So touchy-feely

I cannot keep my color bright!

　　　　　—Frank Webb

Chapter Eight
Size

Size is proportion, ratio, mass or scale. It is the hidden element revealing itself only through the other marks. If a value or a shape is said to be large, we ask, "In relation to what?" Out in the world and in our subject, size is apprehended in relation to our bodies. In pictorial space, the size of a mark is always in relation to other marks. We store up certain standards of size and so it is immediately recognizable when there is a departure from a size norm; for example, Cyrano's nose.

The painter often chooses a standard with which to measure. For instance, in a life class, proportions of the figure are often determined by holding a pencil at arm's length and placing the thumbnail at the length of the head. With this measure any part or all of the figure can be scaled. Psychologically, we impute greater prestige and power to larger sizes.

Size is the simplest statement made to declare space. As the known size of an object diminishes, we take it to be a sign of distance. The first design concern about size is the picture's surface division. Area measures include negative shapes as well. The picture field must be divided into a variety of sizes of contrasting value shapes.

Variety of Size

Get good sizes in your picture by grasping the relationship of occupied space to unoccupied space. Make one larger than the other. Either volumes or space should occupy most of the picture. The Old Masters made volumes dominate, leaving a compressed and intensified space.

We measure mostly in relation to our bodies. If a unit is too large or too small to see, we must use instruments to see it.

Edgar Whitney stressed the need for variety of size, using as examples of size, Papa, Mama and Baby. He suggested Baby be placed between Papa and Mama, and closer to one, thus exciting the size relationship and giving a rhythmical sequence to position. Look at any coin where one image almost fills the circle. Many pictures flunk because they lack a size dominance. Fill your paper or canvas with your major idea. If you have another idea, put it on tomorrow's painting.

Let us apply composition ideas to size relationships. First make many sizes (contrast) but let one be the largest size to get unity. Repetition of sizes should be given to values, shapes, colors, textures or directions. Sizes must be balanced, but as in all picture-balancing acts, sizes are balanced with other weights and forces. Gradation of size generally gives us the wedge shape. Most parts of the human body have gradation. Tree limbs and trunks have size gradation. Change sizes for the sake of expressiveness, or to make a detail readable, such as shingles on a roof.

Size qualifies color areas. Any possible combination of hues, values and intensities can be controlled if size is considered. What looks good in miniature will often look wrong in a larger size. The size of your picture suggests a certain scale of detail. Unless we can walk back to view a very large picture we cannot see it all at once. Therefore, it should contain less detail. A lot of detail would make it more difficult to see *whole*. The eye would get stuck in small attractive incidents.

Sizes of Intervals

Other words for intervals are rests, negative shapes, interstices. These often go unnoticed in a noncomposed painting. You must vary the sizes of intervals between all units. Typically, when three units are positioned, they tend to be placed with equal intervals. It seems to be some human weakness born into us that must be countermanded. Avoid mechanical yardstick spacing.

Invisible, but important, are the sizes of intervals between hues on the color wheel. When combining hues, choose unequal intervals. When selecting a triad, two of the hues should be closer and the third farther around the wheel. The same applies to values. When sketching with two values on white paper avoid having the middle value at the middle. Push your mid-value closer to white or closer to black, thus getting variety in sizes of color intervals. It seems odd to discuss sizes of intervals that are invisible. But there are many invisible things that we accept—the wind, for instance.

Division

Irregularity pays. In a landscape, divide the heavens and the earth unequally. When possible, do not center windows on walls. On trees make the crown larger than the trunk or vice versa. Nature's tree might divide equally but the painted one should not. Avoid equal division in any area, shape or line. If any unit must be divided in a regular manner, for example, a multipane window, make some of the panes different values or colors. Any incident at the picture's edge should not occur at midpoint.

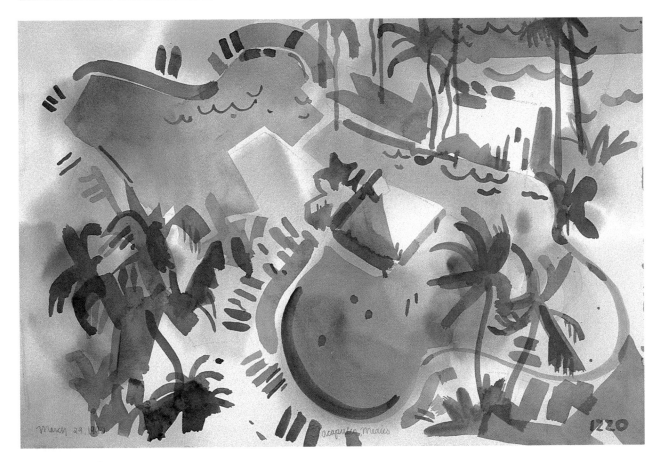

Acapulco, Mexico
© 1990 by Michele Izzo Croft
Watercolor
15″ × 22″

This calligraphic painting has a wide range of sizes, both positive and negative.

Cropping

Photography has conditioned us to the aerial view, the worm's eye view and more to the point, the close-up. Cropping a subject suggests intimacy and sets up a size dominance as well. Extreme cropping may give a feeling of arbitrariness. It is a good idea to avoid cropping at tangents and at joints. Also avoid cropping within a long vertical at the side of the picture, such as cropping through a tree trunk. When calling attention to a single figure on a field, it is helpful to have some part of the figure go off the side borders or at least have a shape or value behind the figure contact the sides. Of course I am not suggesting cropping a finished painting as I would a photo, but making instead a more cautious placement at a preliminary stage. Radical cropping may elicit an undue interest in what goes on beyond your borders.

Biddeford Pool
by Frank Webb
Watercolor
15″ × 22″

Here are two paintings made from one sketch. The top version is made using all the size relationships and objects of the sketch. The bottom version is a close-up, made by cropping the sketch. Each has a different mood. The top version is high in value key, with a yellow-green dominance. The bottom version is a low key and its red-violet color is opposite to the top version.

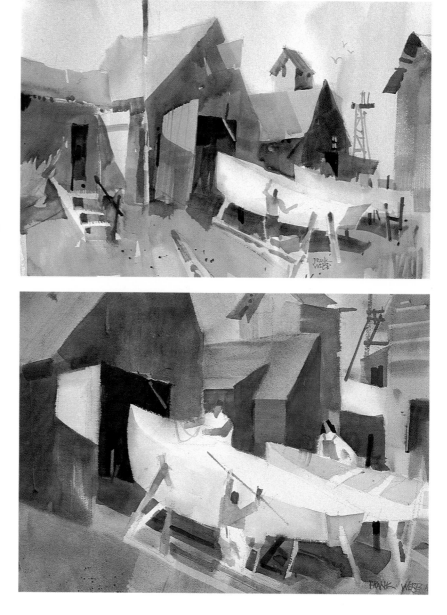

Enlarging

To transcribe a sketch up to a larger paper or canvas, make sure your border line of the sketch is in the same proportion as the format. Make grid lines on both using the same proportional divisions. Draw the salient lines into the rectangles. This is better than using a projector, because when using your eye to make comparisons, you are drawing rather than tracing. Happily, a grid stresses the flatness of your picture. A picture is not a window.

Any square or rectangle can be enlarged or reduced if one uses its diagonal to plot the change.

The grid system may be used to reproportion a drawing as long as the area is divided into the same units and you can live with the distortions.

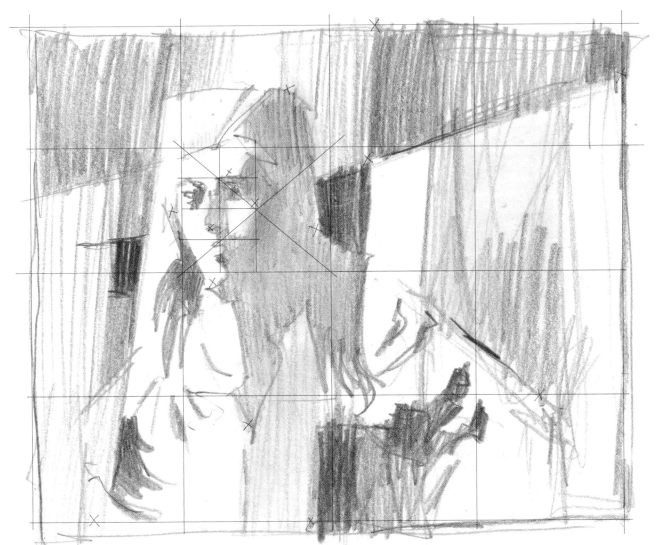

Thoroughly Modern Maud
by Frank Webb
Preliminary pencil sketch
7½″ × 9″

This is a space-breaking experiment using a checkerboard and a continuance. Smaller divisions are made where more accurate transcriptions are needed. I place *x* marks to indicate key points.

The Force Series II
by Don Graeb
Watercolor
12″ × 22″

The sky dominates. The fastest way to unity is with size dominance and a color dominance.

Pear Appeal
© 1991 by Judith Blain
Watercolor
11″ × 22″

The most commanding size belongs to the pear group along with its cast shadows.

The Bingo Game
by Tee Herrington
Watercolor
22″ × 15″

The woman furnishes size dominance.

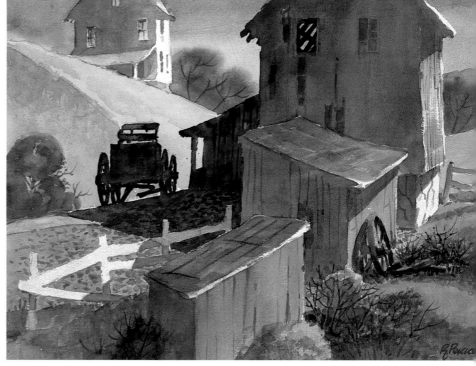

October Obliques
by Randy Penner
Watercolor
18″ × 24″

The dominant size here is the group of farm buildings with wagon attached.

Tulips
© 1982 by Robert Schmalzried
Acrylic
16″ × 20″

A congregated shape of tulips makes the dominant size.

Floral Display
by Lu Priore
Watercolor
22″ × 30″

The bouquet is the same size as the background but it is dominant because it has visual identity and is an assertive shape.

Tips

● Avoid a too extreme contrast of size. One must be able to get all the sizes of the picture's marks in one focus.

● Don't merely copy your subject's sizes. They are only incidental sizes resulting from your vantage point. Enlarge some, reduce others and omit the unnecessary.

● Sometimes your largest piece is not an object, but congregated objects, or a harmony of values, such as a silhouette of a distant city.

● Give marks different lengths, widths and heights, and make varied size intervals between them. One interval should be crowned King.

● Avoid saying two things on one picture. A size dominance prevents this.

● Vitality results from different size marks with strokes of various directions.

● A close-up is more intimate. Make the subject larger and run some of it off the edges. Don't let it float in aerial limbo.

● Whether it's a postage stamp or a giant outdoor billboard, get variety of size in the marks. Three sizes are necessary: large, middle-sized and small. These are the sizes of the things of this world.

● "There is a right physical size for every idea," said Henry Moore.

All my shapes are actualized
In large and small and middle-sized.
It seems completer
With varied meter,
And less boring than when
otherwise.
—Frank Webb

Chapter Nine
Direction

Graphic marks travel in three directions only: horizontal, vertical and slanting. Horizontal marks express repose, stability and calmness. We live in constant relationship to the horizon and to the forces of gravity pulling us toward the horizontal plane. The surface of contained liquid is horizontal. Verticals are more energetic than horizontals. Vertical marks soar, suggesting dignity, and poise. They express life in the sense that some force has erected, grown or stood up from the inert horizontal. The slanting direction expresses both two-dimensional and the three-dimensional movement. Each slant needs an opposing slant mark to balance it.

Each good shape should have direction, that is, it should stretch longer in one direction. Since rounds, dots, squares, equilateral triangles and stars have no direction, they resist integration. They may, however, line up and become directional. The direction of a shape is not only relative to the borders of the picture, but its thrust is relative to the directional forces of neighboring shapes. The best picture formats are the horizontal and the vertical because they have direction resulting from dimensional variety.

Slanting lines originating at borders usually suggest a moving inward toward depth, since the eye believes the picture lies somewhat inward from the border. Vanishing planes of perspective also drive inward toward the horizon line.

Variety of Direction

Variety (contrast) of direction in a picture is achieved by using all three directions. Unity is achieved by making one of the three direc-

tions dominant, by the size of the largest marks or by repetition. Balance of direction is felt by weighing all the picture's forces. Gradation of direction goes from vertical to slant to horizontal with increments between these three extremes.

Continuance

A segment of a line will continue in another line which is going in the same direction. Lines seem to continue as extensions of themselves.

Depth

Movements into depth result from overlapping, plane turning, shifting, linear perspective, parallel perspective, aerial perspective and diminishing of sizes. These movements are the most profound, elusive and challenging problems of pictorial art. (See chapter one for discussion.)

Containment

Keep us in the picture. Do not face images out of the picture. Subjects having a front, such as people, cars and boats, should face inward. When grouping these have them face each other and not be back to back.

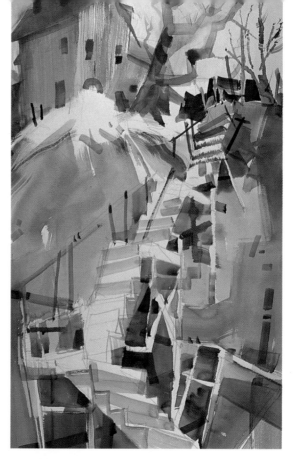

Boyd Hill
by Frank Webb
Watercolor
36″ × 28″

(Left.) Both the format and the staircase express upness. Most interest results from zigzagging.

Victorian Wheeling
by John Barton
Acrylic
12½″ × 31″
Collection of Ms. Charlotte Palmer

(Below.) A neighborhood is perfectly expressed by a long horizontal. Trees, bays and windows offer counterdirection.

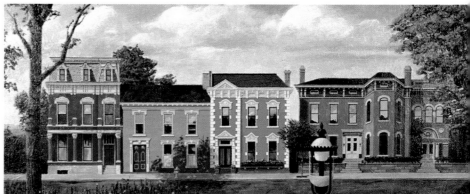

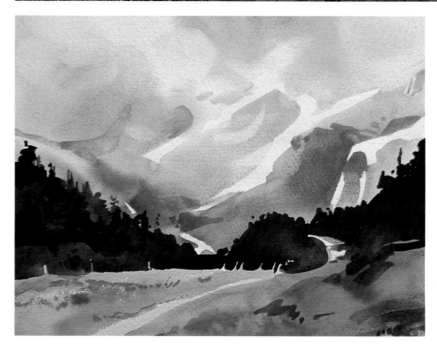

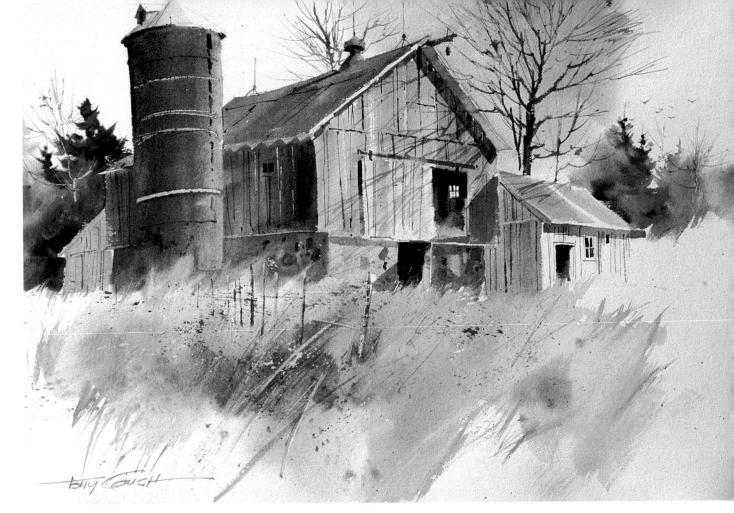

Silo
by Tony Couch
Watercolor
22" × 30"

Mountain Meadow
© 1992 by Judith Blain
Watercolor
16" × 17"

(Left.) A square format lacks reverberation. Energy is initiated here by a radiation of lines from the center.

A vignette builds containment into a painting. A good vignette is not just an oval shape centered on paper; its negative space is planned as it is in Tony's thumbnail sketch, left. See also Lu Priore's vignette on page 54.

Vignette

I define a vignette as an interesting shape of middle value containing darks that is placed in an exciting position on a white background. Each untouched corner of white should be a good shape. There should be variety in their sizes and one should definitely be larger than the others. The axis of positive and negative shapes should be slanting. The shape should touch a border at least once but need not touch all borders. While a small amount of the shape's circumference may be arbitrarily faded away to white, most of the shape's edges should be the edges of recognizable units. Interest is heightened if the shape is given gradation of value, color and intensity. It need not have whites within since there is generous white in its background. White background areas may be enlivened with indications of calligraphic symbols, such as bits of grass, birds in a sky, etc. This helps to signify content in the otherwise-empty whites.

Still Life With Blue Tea Pot
by Irene Marcello
Oil
42″ × 22″

Irene's painting drools with light. Much of its impact results from its large size and vertical format. The tree at right makes the format work. The format is also held together with lace.

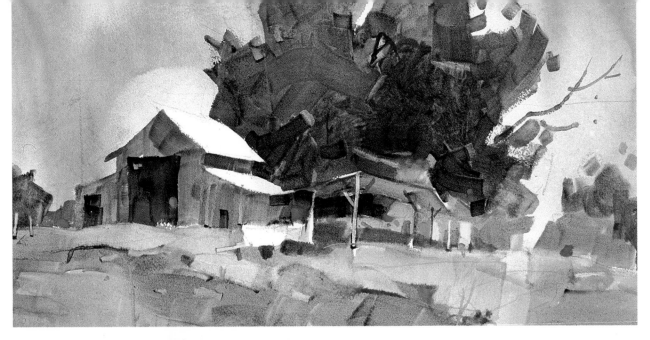

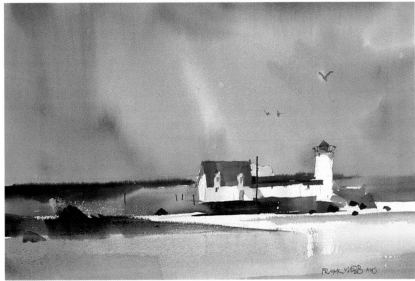

California Landscape
by Frank Webb
Watercolor
13″ × 22″

(Above.) I cropped this painting at top because my foliage shape was somewhat round. Cropping gave the large dark a horizontal direction and made the farm look wider.

Goat Island Light
by Frank Webb
Watercolor
13″ × 22″

(Left.) What is wider than the ocean? Your paper should look like the subject before you begin.

Tips

• A forest interior suggests a vertical dominance; a beach scene, horizontal; and a grain elevator, slanting.

• Don't contradict your subject by an inappropriate format. Vertical formats, especially, need to have a strong rationale for usage; for example, a standing figure or a waterfall.

• Don't run marks to the corners of the picture; they form arrows and lead us out of the picture.

• When composing in slanting directions, include some verticals and horizontals. This not only gives variety but stabilizes the exuberance and keys the picture to its frame.

• A single palm tree needs another with it (composite shape) to improve the shape and to establish a direction.

• Avoid pyramidal angles when designing mountains. Don't go up the mountain at thirty-five degrees and then down the other side at the same thirty-five degrees. Do not repeat the same angles on several mountains. It's boring.

• Tilt or give a slanting direction to every shape. If you slightly tilt a house within the picture it excites the negative shapes.

• Avoid duplicating the direction of your main line. It's usually better to make opposing lines.

• Negative shapes also require varied directions.

Said a painting instructor named
 Brandt,
Who had learned to work on a slant,
"In Taxco I find
I'm rather inclined
To disfavor the painter who can't."
 —Dick Barrett

Chapter Ten
Composing the Self

What kind of an artist are you? Traditionally, artists are lumped into four major categories:

1. Classic. This painter is an idealist, believing the idea determines the work. Concern is for a hierarchy of absolute ideas.

2. Romantic. This painter is one who believes in life's values and in choices, and who is devoted to the actions needed to gain those values.

3. Naturalist. A lover of nature, one who studies the light and shade of objects and who renders a faithful account. Concern is for appearances.

4. Realist. Often confused with a naturalist. This painter combines naturalism with a compositional idea, and elegance of skill. Concern is for the synthesis or aesthetic fusion of nature and composition.

These categories overlap in most painters.

Most painters choose from among landscape, portrait, figure, still life, marine painting, etc. Beginners need wide experience before deciding on a favorite. Your chosen medium often influences the focus of your interest. Do you prefer working on location or in the studio?

Sketch. Take classes. Go to exhibitions. Form opinions. Choose role models. Devour all the fine work of the best museums. Avoid the pack. Patiently persevere until your work ripens.

Finding a Subject

We seek a subject out there, but the real subject is *you*. The following might clarify your relationship to your subject.

☐ I respond to my subject in terms of my medium or environment.

☐ My gallery expects me to paint this subject.

☐ My patron has chosen this subject.

☐ I really enjoy this subject.

☐ This subject allows me to portray elaborate detail.

☐ I paint the figure because it is challenging.

☐ There is an exhibition coming up.

☐ I am well-known for this subject.

☐ This is an exciting new direction for me.

☐ This subject has been awarded prizes lately.

No one should tell you what to paint, or how, or when, or in which medium. However, you will relinquish these decisions if you accept commissions. No harm in that. We all must make a living, but don't be sidetracked. Use your free time to become the artist you originally *meant* to be. Most of us probably notice that some others paint cliché subjects: empty Adirondack chairs, lily ponds, etc. When we notice that we ourselves are using shopworn subjects, we ought to find new material. Of course, in the final argument, art is not in our subject but in our encountering of the subject. The two most unique qualities that impregnate a work of art are a creative concept and an exciting composition. These are the qualities that I seek when judging works of art. Next in order are technique and presentation.

The important conclusion is that at every stage the painter must truly discern what is valid and must at some point leave behind imitation of others. The painter should not be wafted by every aesthetic wind, but must come into focus as a unique personality making unique work. This is difficult in our age of conformity. An assignment for each life was voiced by Socrates who said, "Know thyself." That assignment is doubly difficult for the painter who must not only create a *self* but must create works of art which embody that self.

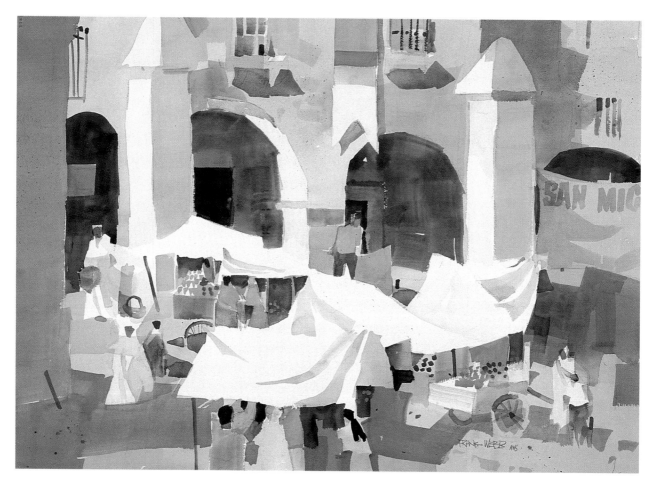

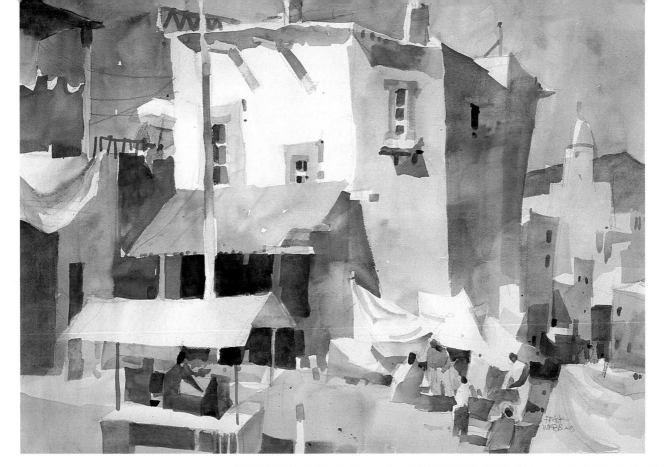

Market Cornered
by Frank Webb
Watercolor
22″ × 30″

(Above.) A market is where goods and ideas are exchanged.

In this painting, cools and warms are mingled throughout to give a feeling of vibration. This helps to express the brilliant Mexican daylight.

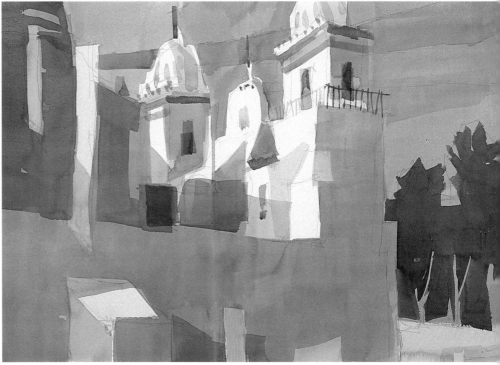

Jardine
by Frank Webb
Watercolor
22″ × 30″

(Left.) Cloths stretch out as magnificent space-breakers. Certainly we need not go to a foreign strand to find our pictures. They are in front of us right now.

Blue Oaxaca
by Frank Webb
Watercolor
15″ × 22″

(Above.) What Mexicans do with space and color is astounding. We should build our paintings with the same devotion.

Being Moved

You cannot communicate an emotion you have not experienced. Since a work of art is feeling communicated through marks on a material surface, you must be intensely involved with the subject and your medium. John Carlson spent his life painting mostly trees. He tried to understand trees. He said, "A tree seldom or never encroaches upon the liberty of another tree." Carlson became quite knowledgeable about his subject because he loved being among trees and immersed in trees. His pictures speak to us because he learned the craft of designing and the mechanics of picturemaking. He learned what to leave out and how to divide his canvas. He imposed form (composition) on his picture.

George Elmer Browne was also a great landscape painter. Notice the magnificent moonlight in his painting (at right) and such restraint of color—pink, lavender and blue-green. More important is his value plan. See how clearly his darks and his lights remain separated from his mid-values. The rhythms of the little boats and the moving light of the tossing ocean show that the painter is involved. He draws us in and compels us to look at these wonderful value shapes.

My teacher, Edgar A. Whitney, was moved by design and by the teaching of design. He often said, "No door will stay closed to a stubborn scholar." His students will attest that Ed would often choke with emotion when he came across a fine work of art, and he often coined aphorisms. Here is a sample: "The ignominy of age is decrepitude—the ignominy of youth is ignorance. If you prefer agility and ignorance to decrepitude and wisdom you sentence yourself to misery half your life." Ed lived a long life, teaching until he was ninety-four.

Frost Bound Stream
by John F. Carlson (1874-1945)
Oil
24″ × 29″
(Left.) Collection of the Parthenon,
Nashville, Tennessee

Night on the Banks
by George Elmer Browne (1871-1946)
Oil
39″ × 39″
(Above.) Collection of the Parthenon,
Nashville, Tennessee

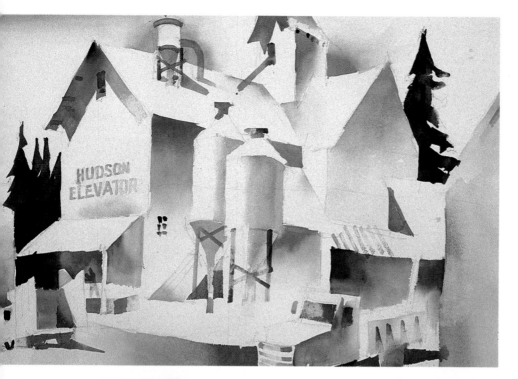

Shade Side
by Frank Webb
Watercolor
15″ × 20″

(Left.) Push-pull values give a real sense of presence but with a degree of apartness.

Iowa Farm
by Frank Webb
Watercolor
15″ × 22″

(Below.) Cool underpainting preceded painting with warm color. You can see the underpainting showing in the end of the large barn and in the sky above.

The Composer's Aim

A composing painter thinks more about marks on paper and less about the subject. The subject is only an excuse for starting the composition. It has no aesthetic value except as a stimulus. The composer looks at the subject and uses it to re-create a new reality. In this new reality the composer does not copy line, shape, values, colors, textures, sizes and directions but re-creates with these marks to make a unique picture. The character of the subject emerges as the whole picture is shorn of irrelevant parts. The picture is painted as much by insight as by eyesight. To understand this, close your eyes after a careful study of a subject. What you see with the eyes closed is what you should paint. This is not to deny seeing but a plea to combine seeing with understanding.

"Art, then, is not what the vulgar think, that is to say, a kind of inspiration which comes from I know not where, and which proceeds at random and presents only the picturesque exterior of things. It is reason itself embellished by genius, but pursuing a necessary course and kept in check by superior laws." — Eugene Delacroix.

Touchstone
by Frank Webb
Watercolor
22″ × 30″

Here the greens are underpainted with purple and other colors to give them the quality of light.

Genesis II
by Barbara Nechis
Watercolor
22" × 30"

Major shapes are drawn with clear water
and paint is dropped in. This procedure
includes several layers. Value gradation
moves from left to right.

Chance Composition

Many serious artists begin with a somewhat random and spontaneous method and work toward images and order. Other artists start with orderly images and hope to spark them with a degree of spontaneity. Simply put: One artist begins with content and works toward form; another artist begins with form and works toward content. The first artist risks chaos and subjectivity. The second artist risks a schematic lifelessness. Regarding risk, remember, each of us is in this alone.

There is an inherent beauty in an automatic, freely made tool mark—a gesture made visible; for example, a coil of rope thrown on the floor. While spontaneous effects have aesthetic interest, they are not art until they are incorporated into a context (composition). As James K. Fiebleman wrote, "Art is a deliberate apprehension of beauty on a material object."

Design and Style

Any painting style benefits from dynamic composition. No one art "ism" has the right to be exempt from compositional needs and no one "ism" can claim to be its sole heir. No particular current vogue influences painting. After a century of modish meandering vitality, we are now on hold.

If there is a discernible trend in painting today it may be toward compositional or designed realism where content is important but not paramount. Designed realism contructs its own reality. In addition to composition it thrives on process— exactly what we have been discussing.

Be a Critic

Your judgment is more important than the opinion of others. If you have compositional ideas in your head you will judge more objectively. It is useful to say, "I like this because . . .," or "I dislike this because . . ."

Technique is only a means to an end. Style is not substance. Reputation is spurious. Popularity is fickle. "Isms" become "wasims." Politics is prurient. But concept and composition are omnipotent— they cross borders of time and space.

Creativity

What is created in a work of art? In a word—relationships. Qualities and relationships which were not there are called into existence. This book is a guide to creativity because it discusses the parts of a painting and teaches how to bring them into relationship. Creativity is a buzz word that evokes forages into the psyche or into outer space. But it is not remote. It takes place in your own studio, right before your eyes, on paper and canvas, as you make your own lines, shapes, values, colors, textures, sizes and directions.

A Jung painter with phobias galore,
Whose pictures were certain to bore,
Composed in Sheyboygan,
Now seldom Freudened,
His psyche's more likely to soar.
—Frank Webb

Megatips

• Compare the noncomposer to the archer who, to be sure of hitting the target, shoots and calls whatever he hits the target.

• Have you ever heard of a mob rushing across town to do good? Perhaps the only two examples I know of are the church and the art association.

• To quote Henry Miller, "I never paint from nature. If I did, I would still be working on the same canvas."

• In show biz there are the actors, the audience, the director, the producer and the critic. The painter must be all of these himself.

• Art is paradoxically aristocratic *and* democratic. Aristocratic because artworks are the most valued objects we rescue from history's scrap heap. Democratic because no one needs a license, diploma, or a membership to practice art. No door is closed because of race, age, gender or class.

• The work of most occupations goes up in smoke. A fine work of art will please for several lifetimes.

• You can buy a good painting for less than a cheap computer.

• The composer is important to the community because society needs those who care about relative values and how things go together.

• As a bird sings so should you paint.

• Some design intuitively, while others claim to do so as a defense for sloth or inability.

• By their works you shall know them.

• Superficial people will be interested in superficial paintings.

• When does a painting become art? Maurice Grosser said, "When it gets sold and starts on a career of its own."

• A painting may be called art when the paper or canvas looks better after the paint is applied.

• Painting is an infection. You catch it from others.

• Art is full of untruths to show us the big truths of life.

• The painting is another body of myself. A fleshed-out idea.

• What is a painting but the recorded tracks of the instruments and gestures of the heart, mind and body of the painter.

• A painting is strong evidence of what you do when you are alone.

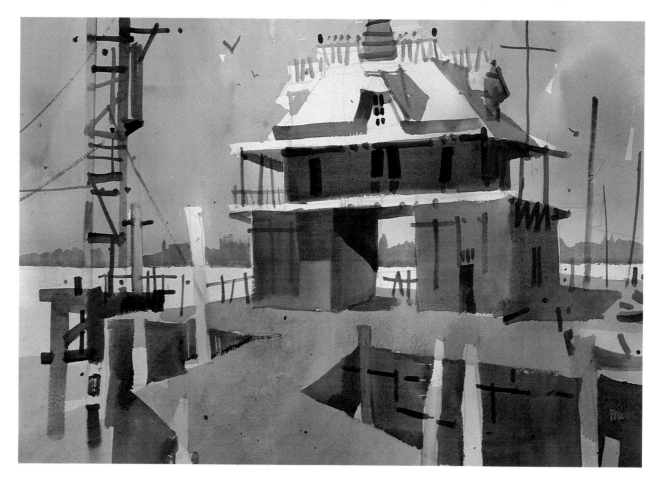

- The painter while painting forgets the world.

- No one has ever quite learned how to paint.

- Nothing in the picture (or in life) is good unless all the parts are in the right place.

- Are you interested in art itself or in art as a springboard from which to launch a public image?

- The truth is not found by a show of hands.

- You are going to need fierce independence. There is little support for a painter. The fun must be in the process itself.

- If your inferiors are sometimes singled out for more honor than you, remember this on some other occasion when you are honored more than a superior.

- If you've never learned to draw the figure or never really learned perspective, why not do it this year?

- If you love a painting or a book, why not drop a note to the artist or the author?

- In spite of whatever you must do to make a living, you still have some time left to practice your craft.

- If you've learned from an art class, buy a piece of work from the teacher. It will clinch your comprehension of the instructor. Buy it also because you will have received more value from the class than you paid for.

- Doctors bury their mistakes, architects plant ivy around their mistakes, and we frame ours and send them off to juried shows.

- The photographer can change size relationships within the picture by changing the station point and changing the lens angle. Nevertheless, there is a certain tyranny of a photograph. Most people be-

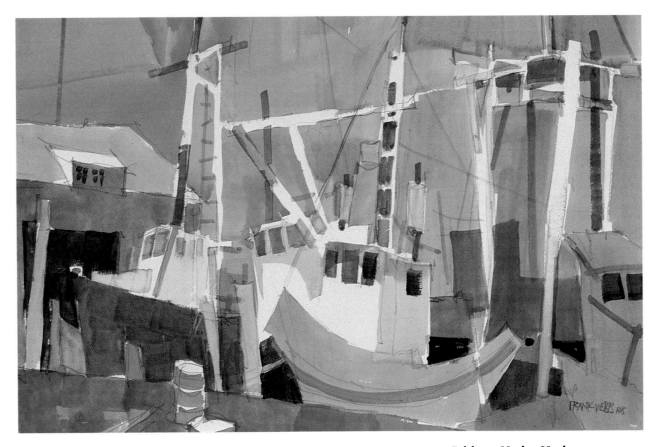

Delaware River Yacht Club
by Frank Webb
Watercolor
15″ × 22″

(Left.) Space is opened with a zigzag movement. A size dominance (the combined wharf and clubhouse) establishes unity.

Fairhope Marina Music
by Frank Webb
Watercolor
15″ × 22″

(Above.) Humor and dashing calligraphy give this statement visual personality. Unity emerges from feeling plus design.

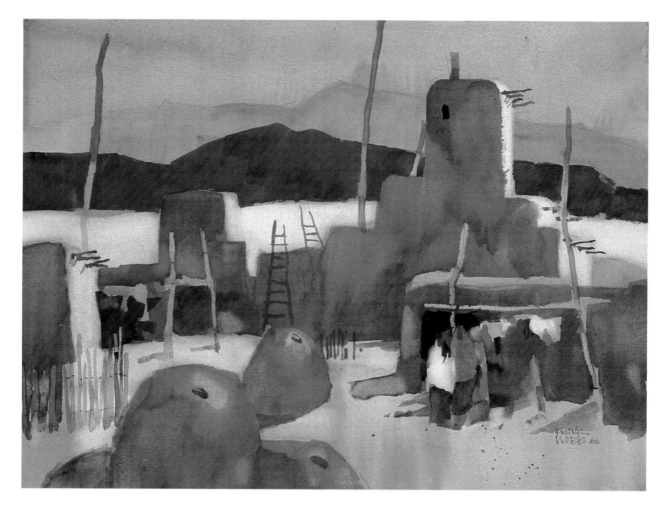

lieve it to be so *factual* that they wouldn't dream of changing its size relationships, value, colors, etc.

• Don't paint from the fingers or wrist. Try the arm. Moreover, make some strokes from the whole torso. Lunge at your work as though you would tame a tiger.

• Money is only one measure of achievement—among others. Cowards and misers rely on it as a rule.

• The painter who is afraid of mistakes is not going to have much fun.

• Would you rather have a little success or a big failure?

• Mistakes are not to be found in the work but inside the self.

• Why should one work in only one medium? Experience in one sheds light on another.

• Though the painter is a poet he must be a good mechanic to build his poetic image.

• The composition of our picture is the plot. The characters, whether they be color or textures, are nothing without the composition. There is no color for color's own sake.

• In the realm of art criticism, charlatanism abounds more than in sports. There, the public is more informed.

• A composed work of art reveals inward order, not the external order of power politics.

• Every painter has a collaborator. Together they are the knowing self and the acting self.

• Each picture you paint, whether

Taos Pueblos
by Frank Webb
Watercolor
22″ × 30″

(Above.) Pueblo shapes are square with rounded corners. The hemispherical oven shapes initiate a contrast, but unity is not threatened since the Pueblo shapes dominate.

Strolling in San Miguel
by Frank Webb
Watercolor
15″ × 22″

(Right.) This is painted on hot-press paper with a warm harmony of earth tones. The picture is stabilized by the dark band across the top.

a landscape or still life, is a portrait — of you.

● All art knowledge is self-taught, but it is not learned in isolation. A teacher gives you an environment and technical help.

● You must become your own critic — know your strengths and weaknesses.

● Just as you must compose by eliminating and ordering the parts of a painting, so too, your life must be divided into meaningful blocks of time — for time is the stuff of life.

● Why not brush up on art history. It will help dispel that silly notion that there is aesthetic progress. If there is progress it is made by the self.

● When you buy a novel or a record you own the art of the author or the musician, but when you buy a reproduction of a painting all you get is a mechanical copy.

● The greatest teacher of painting may be the pencil.

● I don't want to see how well you can add detail or how slick your work is. I want you to show me what grips you. *Draw* me to your drawing.

● Take your shovel and dig deeper in a chosen spot — stop scratching all over the county.

● Regarding the painter who naively thinks that he is composing intuitively: It is a tragedy that one doesn't know what one doesn't know.

● What we want most in life is more life. Our deepest beliefs reflect and fulfill this yearning. On a human level, art intensifies, quantifies and qualifies our personal life. Art, therefore, is closely bound with pleasure.

● There is great injustice among the fine arts. The great and the famous are not the same persons. Great painters can go unnoticed while aesthetic pip-squeaks get publicity and sell well. The low taste of mass marketing and mass media trivialize art.

● Perhaps a picture lives only during the time that one pulls it together as a beholder. A good creative painting calls the viewer into a collaboration. Less interesting paintings tell all but ask nothing. They are imposters.

● Unless a painting is merely part of the decor, it need not match the couch or drapes. Its frame separates it from the real world, but its grip on our heart prevents it from being part of the background.

● You might as well get used to this fact: Not everyone will like your work. Hence the need for independence.

● I find if I admire a painting or a book I will always need it again.

● The painting student often asks, "How do I know when the picture is finished?" The picture is finished when you have expressed your idea. If you have no idea, you will not know when you are finished.

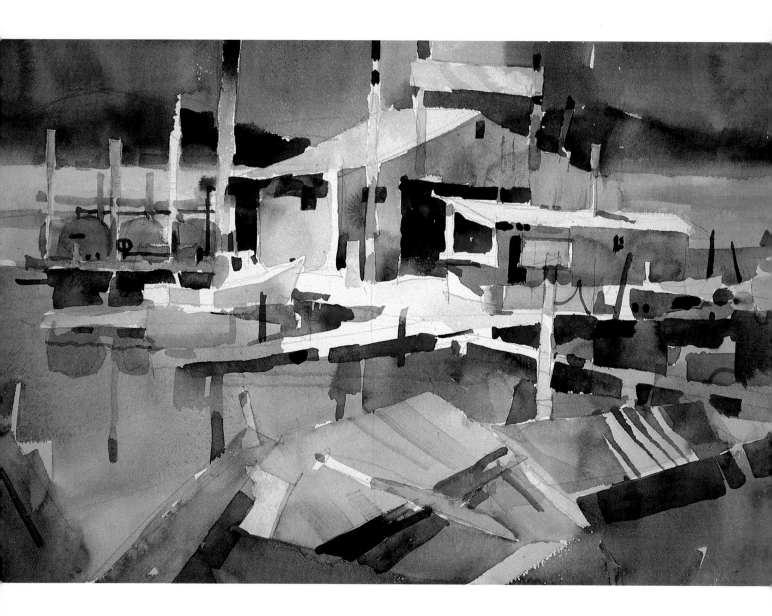

Conclusion

Yaughiogheny Marina
by Frank Webb
Watercolor
15" × 22"

The subject of this picture is shapes. Shift your thinking from objects and subjects to shapes.

I began this book up to the armpits in transparencies, notes and correspondence. I regretted the time it stole from my painting. Over the weeks I pulled together major ideas, sharpened my theme and trashed unrelated data. As the work fleshed out, my excitement mounted. I couldn't put it down. A design works that way for me in a painting, too. The painting begins as a feeling but ends as another body of myself. Therefore, design knowledge not only strengthens the painting but puts backbone into the painter. To know is good. To know that you know is better. The composer acts on impulses with minimal pussyfooting. Nevertheless, compositional skills do not exempt one from anxieties and doubt. They are ever present and are as frightening as political, economical or emotional chaos. Isaac Watts wrote, "Must I be carried to the skies on flowery beds of ease, while others fought to win the prize and sailed through bloody seas?" Compositional know-how gives us a weapon to fight aesthetic phantoms of doubt, fear, discouragement and apathy. It turns all these negatives into yea-saying.

—Soli Deo Gloria

Bibliography

The study of painting is an interdisciplinary subject which must be pursued down labyrinthine ways. In the following lists, about half the books are out of print. Look for them in used book stores and in libraries. Ask your local librarian to initiate an inter-library loan. (These take a little time and are usually free within your state. A modest charge may be levied if the loan is made from out of state or from a university.) If you are a stubborn scholar you will persist.

I envy you your first reading of these books.

Inspirational and Fun

Cary, Joyce
Art and Reality
New York: Doubleday, 1961

Ghiselin, Brewster
Creative Process, The
New York: Mentor Books, 1952

Goldwater and Treves (Editors)
Artists on Art
New York: Pantheon Books, 1972

Gray, Clive (Editor)
John Marin by John Marin
New York: Holt Rinehart and Winston

Grosser, Maurice
Painter's Eye, The
New York: Mentor Books, 1956

Guerard, Albert L.
Art for Art's Sake
New York: Schocken Books, 1963

Hawthorne, Mrs. Charles W. (Collected by)
Hawthorne on Painting
New York: Dover Publications, 1960

Henri, Robert
Art Spirit, The
New York: Lippincot Company, 1939

Hunt, William Morris
On Painting and Drawing
New York: Dover Publications, Inc., 1976

Huxley, Aldous
Doors of Perception, The
New York: Harper & Row, 1954

L'Engle, Madeleine
Walking on Water
Reflections on Faith and Art
Toronto: Bantam Books, 1980

May, Rollo
The Courage to Create
New York: Bantam Books, 1976

Protter, Eric
Painters on Painting
New York: Grosset & Dunlap, 1971

Rookmaker, H.R.
Modern Art and the Death of a Culture
London: Inter-Varsity Press, 1971

Shawn, Ben
Shape of Content, The
Cambridge: Harvard University Press, 1957

Sloan, John
Gist of Art
New York: Dover Publications, 1977

Van Gogh, Vincent
Letters of Vincent Van Gogh, The
New York: Atheneum, 1963

Wolfe, Tom
Painted Word, The
New York: Bantam Books, 1975

Philosophy and Aesthetics

Bell, Clive
Art
New York: Capricorn Books, 1958

Berenson, Bernard
Seeing and Knowing
Greenwich, Connecticut: New York Graphic Society, Ltd., 1953

Cheney, Sheldon
Expressionism in Art
New York: Liveright, 1962

Collingwood, R.G.
Principles of Art
New York: Oxford University Press, 1972

Fiebleman, James K.
Aesthetics
New York: Humanities Press, 1968

Fiebleman, James K.
Quiet Rebellion, The
New York: Horizon Press, 1972

Gilson, Etienne
Painting and Reality
New York: Meridian Books, 1957

Langer, Susanne K.
Feeling and Form
New York: Scribner's Sons, 1953

London, Peter
No More Secondhand Art
Boston: Shambhala Publications,
1989

McLuhan, Marshall
Gutenberg Galaxy, The
Toronto: University of Toronto
Press, 1962

Meyer, Leonard B.
Music, The Arts, and Ideas
Chicago and London: The University of Chicago Press, 1967

Panofsky, Erwin
Meaning in the Visual Arts
New York: Doubleday, 1955

Philipson, Morris
Aesthetics Today
New York: The World Publishing
Co., 1968

Rand, Ayn
Romantic Manifesto, The
New York: The New American
Library, Inc., 1975

Read, Herbert
Art and Society
New York: Schocken Books, 1966

Read, Herbert
To Hell With Culture
New York: Schocken Books, 1964

Reid, Louis Arnaud
Meaning in the Arts
New York: Humanities Press, 1969

Santayana, George
Reason in Art
New York: Dover Publications,
1982

Stein, Leo
*Appreciation: Painting Poetry
and Prose*
New York: Random House, 1947

Webb, Frank
Watercolor Energies
Cincinnati: North Light Books,
1983

Spatial

Kandinsky, Wassily
Point and Line to Plane
New York: Dover Publications,
Inc., 1979

Leepa, Allen
Challenge of Modern Art, The
New York: A.S. Barnes and Company, Inc., 1961

Loran, Erle
Cézanne's Composition
Berkeley and Los Angeles: University of California Press, 1970

Composition and Picture Making

Albers, Joseph
Interaction of Color
New Haven: Yale Press, 1963

Barratt, Krome
Logic & Design
New York: Design Press, 1980

Brandt, Rex
Seeing With a Painter's Eye
New York: Van Nostrand Reinhold,
1984

Carlson, John F.
*Carlson's Guide to Landscape
Painting*
New York: Dover Publications,
Inc., 1973

Graham, Donald W.
*Composing Pictures, Still and
Moving*
New York: Van Nostrand Reinhold,
1983

Graves, Maitland
Art of Color and Design, The
New York: McGraw-Hill Book Company, Inc., 1951

Gombrich, E.H.
Art and Illusion
Princeton: Princeton University,
1956

Henning, Fritz
Concept and Composition
Cincinnati: North Light Books,
1983

Kepes, Gyorgy
Language of Vision
Chicago: Paul Theobald, 1944

Loomis, Andrew
Creative Illustration
New York: Viking Press, 1947

Richter, Jen Paul (Editor)
Notebooks of Leonardo DaVinci
(Two volumes)
New York: Dover, 1970

Sargent, Walter
The Enjoyment and Use of Color
New York: Dover Publications,
Inc., 1964

Taylor, John F.A.
*Design and Expression in the
Visual Arts*
New York: Dover Publications,
1964

Webb, Frank
Webb on Watercolor
Cincinnati: North Light Books,
1990

Index

Improve your skills, learn a new technique, with these additional books from North Light

Business of Art

Artist's Market: Where & How to Sell Your Art (Annual Directory) $22.95

Artist's Friendly Legal Guide, by Floyd Conner, Peter Karlan, Jean Perwin & David M. Spatt $18.95 (paper)

Handbook of Pricing & Ethical Guidelines, 7th edition, by The Graphic Artist's Guild $22.95 (paper)

Watercolor

Alwyn Crawshaw: A Brush With Art, by Alwyn Crawshaw $19.95

Basic Watercolor Techniques, edited by Greg Albert & Rachel Wolf $16.95 (paper)

Buildings in Watercolor, by Richard S. Taylor $24.95 (paper)

The Complete Watercolor Book, by Wendon Blake $29.95

Fill Your Watercolors with Light and Color, by Roland Roycraft $28.95

How to Make Watercolor Work for You, by Frank Nofer $27.95

The New Spirit of Watercolor, by Mike Ward $21.95 (paper)

Painting Nature's Details in Watercolor, by Cathy Johnson $22.95 (paper)

Painting Outdoor Scenes in Watercolor, by Richard K. Kaiser $27.95

Painting Watercolor Florals That Glow, by Jan Kunz $27.95

Painting Watercolor Portraits That Glow, by Jan Kunz $27.95

Painting Your Vision in Watercolor, by Robert A. Wade $27.95

Ron Ranson's Painting School: Watercolors, by Ron Ranson $19.95 (paper)

Splash 2: Watercolor Breakthroughs, edited by Greg Albert & Rachel Wolf $29.95

Tony Couch Watercolor Techniques, by Tony Couch $14.95 (paper)

The Watercolor Fix-It Book, by Tony van Hasselt and Judi Wagner $27.95

The Watercolorist's Complete Guide to Color, by Tom Hill $27.95

Watercolor Painter's Solution Book, by Angela Gair $19.95 (paper)

Watercolor Painter's Pocket Palette, edited by Moira Clinch $16.95

Watercolor: Painting Smart!, by Al Stine $21.95 (paper)

Watercolor Tricks & Techniques, by Cathy Johnson $21.95 (paper)

Watercolor Workbook, by Bud Biggs & Lois Marshall $22.95 (paper)

Watercolor: You Can Do It!, by Tony Couch $29.95

The Wilcox Guide to the Best Watercolor Paints, by Michael Wilcox $24.95 (paper)

Mixed Media

Alwyn Crawshaw Paints on Holiday, by Alwyn Crawshaw $19.95

Alwyn Crawshaw Paints Oils, by Alwyn Crawshaw $19.95

Basic Drawing Techniques, edited by Greg Albert & Rachel Wolf $16.95 (paper)

Basic Landscape Techniques, edited by Greg Albert & Rachel Wolf $16.95

Basic Oil Painting Techniques, edited by Greg Albert & Rachel Wolf $16.95 (paper)

Being an Artist, by Lew Lehrman $29.95

Bringing Textures to Life, by Joseph Sheppard $21.95 (paper)

Capturing Light & Color with Pastel, by Doug Dawson $27.95

Colored Pencil Drawing Techniques, by Iain Hutton-Jamieson $24.95

The Complete Acrylic Painting Book, by Wendon Blake $29.95

The Complete Book of Silk Painting, by Diane Tuckman & Jan Janas $24.95

The Complete Colored Pencil Book, by Bernard Poulin $27.95

Tony Couch's Keys to Successful Painting, by Tony Couch $27.95

Creative Painting with Pastel, by Carole Katchen $27.95

Dramatize Your Paintings With Tonal Value, by Carole Katchen $27.95

Drawing & Painting Animals, by Cecile Curtis $12.50

Drawing: You Can Do It, by Greg Albert $24.95

Energize Your Paintings With Color, by Lewis B. Lehrman $27.95

Exploring Color, by Nita Leland $24.95 (paper)

The Figure, edited by Walt Reed $17.95 (paper)

Foster Caddell's Keys to Successful Landscape Painting, by Foster Caddell $27.95

Getting Started in Drawing, by Wendon Blake $24.95

Handtinting Photographs, by Martin and Colbeck $29.95

How to Paint Living Portraits, by Roberta Carter Clark $28.95

Keys to Drawing, by Bert Dodson $21.95 (paper)

Light: How to See It, How to Paint It, by Lucy Willis $19.95 (paper)

The North Light Illustrated Book of Painting Techniques, by Elizabeth Tate $29.95

Oil Painter's Pocket Palette, by Rosalind Cuthbert $16.95

Oil Painting: Develop Your Natural Ability, by Charles Sovek $29.95

Oil Painting: A Direct Approach, by Joyce Pike $22.95 (paper)

Oil Painting Step by Step, by Ted Smuskiewicz $29.95

Painting Animals Step by Step by Barbara Luebke-Hill $27.95

Painting Flowers with Joyce Pike, by Joyce Pike $27.95

Painting Landscapes in Oils, by Mary Anna Goetz $27.95

Painting More Than the Eye Can See, by Robert Wade $29.95

Painting the Beauty of Flowers with Oils, by Pat Moran $27.95

Painting the Effects of Weather, by Patricia Seligman $27.95

Painting Towns & Cities, by Michael B. Edwards $24.95

Painting Vibrant Children's Portraits, by Roberta Carter Clark $28.95

Painting with Acrylics, by Jenny Rodwell $19.95 (paper)

Pastel Interpretations, by Madlyn-Ann C. Woolwich $28.95

Pastel Painter's Pocket Palette, by Rosalind Cuthbert $16.95

Pastel Painting Techniques, by Guy Roddon $19.95 (paper)

The Pencil, by Paul Calle $19.95 (paper)

Perspective Without Pain, by Phil Metzger $19.95

The Pleasures of Painting Outdoors with John Stobart, by John Stobart $19.95 (paper)

Putting People in Your Paintings, by J. Everett Draper $19.95 (paper)

Realistic Figure Drawing, by Joseph Sheppard $19.95 (paper)

Sketching Your Favorite Subjects in Pen and Ink, by Claudia Nice $22.95

Tonal Values: How to See Them, How to Paint Them, by Angela Gair $19.95 (paper)

To order directly from the publisher, include $3.00 postage and handling for one book, $1.00 for each additional book. Allow 30 days for delivery.

**North Light Books
1507 Dana Avenue
Cincinnati, Ohio 45207**
Credit card orders
Call TOLL-FREE
1-800-289-0963

Prices subject to change without notice.